ii

HOLLYWOOD FOTO-RHETORIC
THE LOST MANUSCRIPT

TEXT BY BOB DYLAN

PHOTOGRAPHS BY BARRY FEINSTEIN

SIMON & SCHUSTER

NEW YORK LONDON TORONTO SYDNEY

A CONVERSATION WITH BARRY FEINSTEIN

Barry, how did you first make your way to Hollywood?

How did I make my way to Hollywood? I drove there.
I wanted to get into the movie business. I was working
for Columbia Pictures at the time for Harry Cohen as a
production assistant.

*How did Hollywood Foto-Rhetoric begin? Is this a
combination of different photographic projects?*

No, it wasn't that glamorous. I thought Hollywood would
make a good essay. So I started making all the pictures
that looked weird. Like the cars in the garage, the Rolls-
Royce in front of unemployment, and all of those things.
Just shot them and shot them and shot them and I hoped to
someday do something with them.

*And what gave you the idea to have Bob Dylan write the
text for the photos?*

I just met him in New York and I liked him and I liked
his music. I liked the songs that he wrote and I asked
him if he'd like to do it, and sure enough he came out to
California and took the pictures [from me] and wrote 'em.
Easy as that. He hit it right on the head. I mean they really
made the pictures more interesting, I think.

*How does it feel to revisit these particular photos after so
many years?*

Well, you know, I never lost track of them. I always
thought about them and often looked at them and it was
good to get them finally out of the file.

*After the lifetime that you've spent behind the camera,
what has been the best part of the job for you?*

Just traveling, taking great commissions to do different
projects, album covers, stories. You know, Dylan and
I drove across country. Well, Bob's manager, Albert
Grossman, was a good friend of mine. He bought a Rolls-
Royce and I was going to drive it back to New York for
him. In the interim, the transmission blew out. So I had to
take it to Denver and had the transmission reworked and I
went back to New York and I said to Albert, "You know,
you gotta get someone to drive this." And Albert asked
me, "So won't you do it?" I said, "You know, I don't want
to do it alone." And Bob was in the office. So I said, "Bob,
you wanna go with me?" He said, "Sure." So we went to
Denver and we both drove the car back. And it was really
a great adventure.

That's terrific. How long did it take you to do that?

Oh, I don't remember. But you know we drove through
Nebraska one night chasing a train, blowing the horn. We
went to, oh, a revival meeting, a church, you know, holy
rollers, and you know we're under a tent and all these people
asking what kind of car it was. People, you know, in Iowa,
never saw a Rolls-Royce. So that was a great experience.

*When you were in the darkroom developing all of these
pictures, did you find yourself listening to Bob Dylan's songs?*

I loved it. I lived with his music. He's my favorite. I think
he's a genius. To listen to his music is really wonderful.
That's why I went out on the road with him. To hear him
come out and sing "Forever Young" or "Blowing in the
Wind" just makes the hairs on your neck stand up.

*As an acclaimed celebrity photographer of musicians and
movie stars, what is the difference for you in photographing
famous subjects versus anonymous ones?*

I like anonymous subjects. It's all about making the picture,
you know? That moment of truth. I mean, you only have
a moment to do it and get it. Because unlike the movie
camera, which keeps rolling and rolling and you get a lot
of takes, you only have one moment to get it, one picture.
But musicians are actually easier to photograph than movie
stars; they'd just not be as uptight . . . in my experience.

*And finally, for somebody coming to this book and
beginning to look at it, what sort of introduction to your
work would you offer?*

I hope they understand it. Well, I hope they enjoy it. And
don't take it seriously. It's only Hollywood.

A CONVERSATION WITH BOB DYLAN

How did you first meet Barry?

Barry and I met in my manager's office. Barry was either courting or was already married to Mary Travers from Peter, Paul & Mary. I knew Mary, too, and she might have introduced him to me at an earlier date, but I don't remember.

Did you guys become friends?

We became traveling partners. Barry was on some tours of mine and we also drove a car across the country once.

Did you like Barry's photography?

Yeah. I liked Barry's photos a lot. They reminded me of Robert Frank's photos.

In what way?

Just in their stark atmosphere. Obviously the subject matter. I liked the angles Barry used in the pictures . . . the shadows and light, that sort of thing.

When did Barry approach you about writing the text?

I don't think he ever approached me about writing anything. I think it was something that sort of happened spontaneously.

Do you consider these poems?

You'd probably have to ask some academician about that.

But what about you?

But what about me? Well I would have to refer to the academicians too. If they are poems, or if they are not poems . . . does it really matter? And who would it matter to?

Do you remember writing the text?

Actually, no.

What do you think of them looking back after all these years?

First of all I don't think what I had written would have been written without seeing the photographs . . . and secondly . . . well I don't know if there is a secondly.

What do you think of the photographs?

Well obviously I thought a great deal of the pictures. I think Barry was an incredibly great photographer as I still do to this present day.

FOREWORD

BY *Luc Sante*

In 1966, beginning in February, Bob Dylan played forty-three concert dates in locations ranging from Kentucky to Australia to Paris. The best known part of the tour, on which he was backed by the Hawks, was the European leg, particularly the May 17 show at the Free Trade Hall in Manchester, England, recordings of which were long erroneously identified as the "Royal Albert Hall" show. That same month he released *Blonde on Blonde*. He faced a further sixty-four scheduled concerts that year, but on July 29 he suffered a motorcycle accident in Woodstock, New York, which sidelined him for a considerable time. Although the initial rumors had it that Dylan was seriously injured, possibly in life-threatening ways, it has since been said that the crash may have actually saved his life, since he was dangerously overworked and exhausted.

Barry Feinstein photographed the 1966 European tour, resulting in indelible images: Dylan playing with children in the streets of Liverpool, strutting onstage in Paris in his houndstooth "rabbit suit" with a giant American flag behind him, wearing dark glasses in the back of a limousine whose windows are filled with the squashed faces of fans peering in. Earlier Feinstein had taken the dramatic angry-young-man portrait for the cover of *The Times They Are A-Changin'*. He had also done a good deal of magazine work, been still photographer on a number of movies, and the following year would be a cameraman for *Monterey Pop*.

Sometime in 1964 Dylan wrote a suite of twenty-three poems inspired by Feinstein's photographs of Hollywood, a spectacular collection taken over the course of the early 1960s. Although the photographs were made for a variety of assignments and in a number of different contexts, they have a remarkable consistency and a clearly identifiable theme: the passing of old Hollywood. The studio system and all that went with it, the industry that had created the movies

as we knew them from the 1920s onward, had reached its terminus at last. It was a subject that clearly resonated with Dylan. He was a major part of the wave of change that was in the process of overthrowing the old guard, but then again, as he wrote in *Chronicles* about 1941, the year of his birth, "If you were born around this time or were living and alive, you could feel the old world go and the new one beginning. It was like putting the clock back to when B.C. became A.D. Everybody born around my time was a part of both."

And obviously Dylan carried Hollywood within him, maybe even more so than the average citizen of his generation. He undoubtedly learned how to pose from them—he was a movie star long before he ever made a movie. He feels like Jayne Mansfield and Humphrey Bogart (as well as Sleepy John Estes and Murph the Surf) in the notes to *Bringing It All Back Home*. And Jean Harlow memorialized by Louella Parsons lies just under his hand on the cover. And in the 1958 film of *Cat on a Hot Tin Roof*, Paul Newman says, "You don't know what love is. To you it's just a four-letter word." And in Don Siegel's movie *The Lineup* (also 1958), a character says, "When you live outside the law you have to eliminate dishonesty."[1] In the European tour pictures of 1966 you can sense Dylan and Feinstein conspiring to make an epic silver-screen performance—if in stills, and only partly premeditated.

So it's hardly surprising that Dylan knew very well what to make of pictures of Gary Cooper's funeral, and Marilyn Monroe's house the day of her death, and Marlon Brando being counterpicketed by racists while he marched on behalf of

1 I owe these two citations to the indefatigable Michael Gray. *Song and Dance Man III*. London and New York: Continuum, 2000, p. 550.

equal housing—as well as of pictures of casting agents and wardrobe department shelves and homes-of-the-stars map peddlers and the unemployment bureau and the Hal Roach Studios slated for demolition. He could inhabit the landscape from one end to the other.

And indeed the poems are not descriptive, but come from within the photographs, as if the pictures themselves were speaking.

> from the outside
> lookin in
> every finger wiggles
> the doorway wears long pants
> an slouches
> no rejection
> all's fair
> in love and selection

Now and then there are echoes of Dylan's songs: "touch me mama / it's all right / it doesn't matter / it's been too well proven / that even I, myself / am not really here." Or "on lease / get piece / sucked in / on a habit / gotta have it / promised by / the prostitute / destroyed ruins / tilt the day"—which could be sung to the tune of "Subterranean Homesick Blues." Overall, though, the voice sounds closest to that of "11 Outlined Epitaphs" (the notes to *The Times They Are A-Changin'*) and "Some other kinds of songs . . ." (the notes to *Another Side of Bob Dylan*). Here as there the lines are skinny, the rhythms abrupt, the language sparse and telegraphic and abbreviated, the situations jarring and dreamlike, the comebacks frequent and snappy. There are laments, complaints, musings, skits (a hilarious screen test, for

one), parables (converting those wardrobe department shelves into a repository of human lives), nightmare scenarios (the lurching paranoid fantasy that begins "after crashin the sportscar / into the chandelier" and sounds like a hellish rewrite of "Bob Dylan's 115th Dream"), and plenty of dry tombstone epigraphs.

The one graphically autobiographical item is the last. Apparently inspired by photographs of William Wyler's Oscar for *Ben Hur* (1959), Dylan considers what happened on December 13, 1963, when he was given the Tom Paine Award by the Emergency Civil Liberties Committee. On the dais without a prepared speech, he had failed to attend the protocol of the liberal worthies in the room, particularly offending them by saying, ". . . I have to be honest, I just got to be, as I got to admit that the man who shot President Kennedy, Lee Oswald, I don't know exactly where—what he thought he was doing, but I got to admit honestly that I, too—I saw some of myself in him." He was booed; some of those present broke off with Dylan. While on the one hand passions ran high on the subject just then—Kennedy's assassination had occurred only three weeks earlier—and on the other Dylan was already beginning to refuse to behave like the fair-haired boy of the protest establishment, there was hypocrisy and cowardice in the audience's response. Here Dylan writes:

> i could've stopped
> an asked
> "is there one person
> out there who does
> not believe he could
> say the same thing"

Then he went home with his statuette and "looked into its eyes . . . pretended it was a barbell." By this point the problem is no longer the smugly righteous audience, but the nature of celebrity and its idiot fetishes—"priceless / but for the worthless space it took."

It makes sense that *Hollywood Foto-Rhetoric* is not just the collaboration of two great artists, but also the overlay of two crashing trains: the collapsing feudal system of old Hollywood and Dylan's eventual disillusionment with the world of celebrity. This not to say that the outlook is sour. Quite to the contrary, Dylan can see the humor and fancy involved as well as the death and dread. But he can appreciate Hollywood from the inside by now, seeing it as a system that requires an elaborate mandarin code of behavior in exchange for a reward that, like Stephen Crane's ball of gold in the sky, looks a lot more like clay when viewed up close. Perhaps writing these poems was for Dylan an early step in the long and arduous process of making his peace with fame and realizing that he could not ever stop being Bob Dylan.

> yes mama i'm an actor
> the difference being my contradiction
> that i
> do not really wish t be remembered
> for my smile
> nor for my costume
> but in complete reversal
> as i look around
> i realize
> that i will be

BY *Billy Collins*

> "It's the difference between the words on paper and the song. The song
> disappears into the air, the paper stays."
> —Bob Dylan

Whenever the question comes up—and it does nearly every semester—of whether
or not rock lyrics qualify as poetry, I offer my students a simple but heartless test.
Ask all the musicians to please leave the stage and take their instruments with
them—yes, that goes for the backup singers in the tight satin dresses, and the
drummer—and then have the lead singer stand alone by the microphone and read
the lyrics from that piece of paper he is holding in his hand. What you will hear can
leave only one impression: the lyrics in almost every case are not poetry, they are
lyrics. Some are good lyrics ("A Whiter Shade of Pale"), others not so good ("Hats
Off to Larry"), but certainly lines like "Come on, baby, light my fire," repeated
many times, do not, and were never meant to, hold up on their own without the
music. Of course, then it's time to mention the few exceptions, and the top spot on
that short list is perennially reserved for Bob Dylan. "When you're lost in the rain
in Juarez / And it's Eastertime too" or simply "You walk into the room / With a
pencil in your hand" can get along fine unsupported by music. That what Dylan
wrote as poetry is poetry, too, should come as no surprise to anyone, least of all
Christopher Ricks, the professor who was inspired to write an exhaustive, five-
hundred-page literary study of the entire Dylan songbook.

The book at hand is an unusual mix: a series of Dylan's poems written in the
mid-sixties in response to images of Hollywood life by photographer Barry
Feinstein—a kind of photo-ekphrastic venture. The poems are the first of his
to appear in print since the more rambling but often hilarious *Tarantula* (1971),
and they provide an uncommon look at literary Dylan, silent on the page. The

poems should sound familiar because of the ways in which they resemble his lyrics. His distinctive singing voice may even seem missing, but we gain the look of the printed words marked by Dylan's quirky abbreviations as well as the shape of the poems, usually as skinny as a teetering column of poker chips stacked on the page in tightly sawed-off lines.

Also recognizable are Dylan's cadence, his verbal energy, and his slangy, at times insinuating tone, which seems even more maverick and antiliterary without the distinctive rasp of his voice. You might even begin to hear the hard strumming of a guitar, the in-and-out breathing of a harmonica, and a vaguely Dylanesque tune playing faintly in the background. The themes, too, are cousins to those of his sometimes withering lyrics ("you're nothin but your mask / you are actin all the time / even when you're playin you"). And quite audible are echoes of some of his better-known songs ("ah mama but it's so hard").

The poems are marked by unexpected bursts of surrealism, lines that seem pulled out of a hat or caught falling from the sky rather than simply written down. And there are Dylan zingers, remarks that jump out of the blue apropos of nothing: "I really have nothing / against / marlon brando." But mostly, it is the voice itself that forms a bridge between these poems and his lyrics, issuing forth as it does from the same slippery persona who can shift moods and even identities from line to line, slipping away mercurylike from any effort to hold him in a single focus. A few poems even end with the vanishing of the poet: "it's been too well proven / that even I, myself / am not really here" and "going / going / gone / an never no more / returnin back."

Like poets with a knack for holding our attention, Dylan knows when to coast and when to accelerate. He will run with some standard blues lines, then tighten

the poem with an arresting image that takes us down the rabbit hole into another dimension where "the doorway wears long pants" and "a jeweled goose" shouting "gobble gobble" appears on the dashboard, all of which makes perfect sense if you are on the right drug or if you even remember what it was like to be on it. Or if you have only tasted the weird milk of the French symbolists.

Some of the poems respond directly to the Hollywood of the black-and-white photographs with which they are partnered. One reenacts a casting director's inquisition of an actress by the name of "conny rainbow"; another captures the spectacle of a movie premiere ("favored first niters / furs reserved / perfume for the face preserved"); another lampoons a romantic comedy ("boy meet girl / cokes t coax"); and the Oscars themselves ("i couldnt tell if it was me / or this thing / i was holding") do not escape Dylan's satiric attention.

These poems are true to the roots of folk and blues, but they also arise from the poetry of the period, especially that of Allen Ginsberg, with whom Dylan had a lifelong acquaintance, and whose *Howl* had the same bombshell effect on the young folk singer as it did on anyone who was paying attention. Dylan's surrealistic novelties compete with Ginsberg's "hydrogen jukebox," and his freedom to move by association is thanks to the liberation achieved by Ginsberg, Kerouac, Gregory Corso, and other Beat writers. As a fellow enemy of falsity and a seeker of authenticity, Dylan is well known for kicking down cardboard fronts. Hollywood's masking, fakery, idolatry of celebrity, and downright kitsch must have provided irresistible targets for the twenty-five-year-old Dylan. And yet he finds something truly mournful in the death of Marilyn Monroe, memorializing her here in a tender eight-line elegy.

Like true haiku and the poems of Emily Dickinson, Dylan's poems bear no titles, no banners waving at the top of the page telling us what to think before we have read the first line. We need not push through the turnstile of a title to enter the poem; rather the words begin the way a song begins, without the dubious benefit of an announcement.

Readers of all kinds will bring to these poems their own curiosities and anticipations; the work signals the appearance of a poetic Dylan on the page not previously witnessed. Plus, the poems have the distinction of being resurrected from the cultural turmoil of the mid-sixties and thus salvaged from the obliteration of time. Not that the poems were ever truly "lost" in the way that mittens and some of the theorems of Pythagoras are lost; rather, they were just set aside and forgotten until the photographer came across a manila envelope one day, opened it up, then picked up the phone and called Bob Dylan with a good idea for a book. And, as you will see, a good idea for a book it was.

HOLLYWOOD FOTO-RHETORIC

THE LOST MANUSCRIPT

I

i, francis x

am here tonite t assure everybody

that nobody has lied t you

you who've dug deeper

into the prints of mankind an humanity

do not listen t those

who tell you you're behind the times

you have had excellent guidance

an you have had the best helpers

t light the way

t them, you are their only interest

you have no reason t feel cheated

no matter what anyone says

just think of your children

for they are the ones that are profitin

an you'll know for you,

kind friends,

time, indeed, is not standin still

2

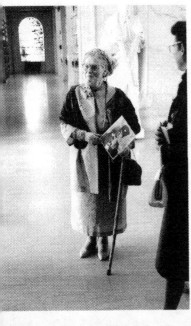
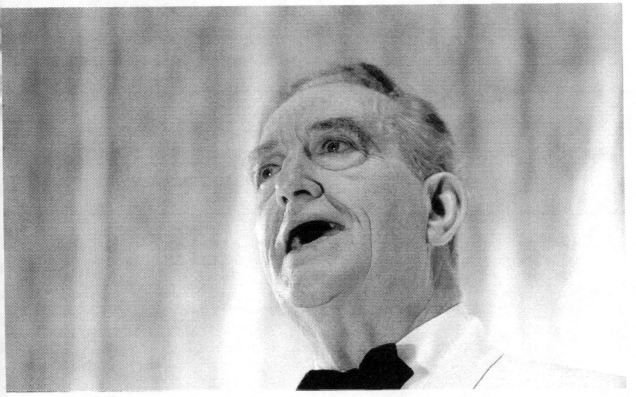

2

madness

stoned madness

leaps insanely tickles at my nerves

whispers

your mask is waitin

proclaimin them most free from guilt

it is waitin impassionately

yes when thinkin cries

were piercing forth

repetition

pushed me off the edge

teachers travel

in strange grabs

that my screams were only

backstage chatter

climbin out of

mouth well-molded

tears warped. stiffly drawn

chizled out by chalk

carved from the best unchosen eyes

t take my place too

in the garden of shadows

how many times then

4

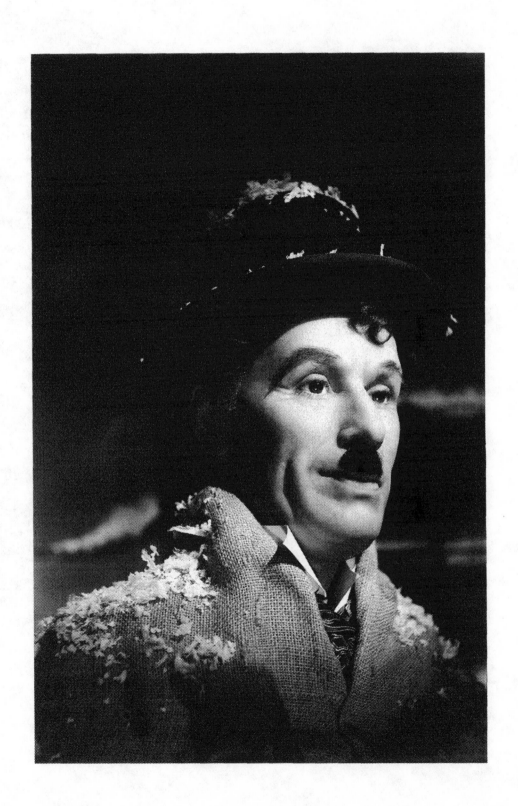

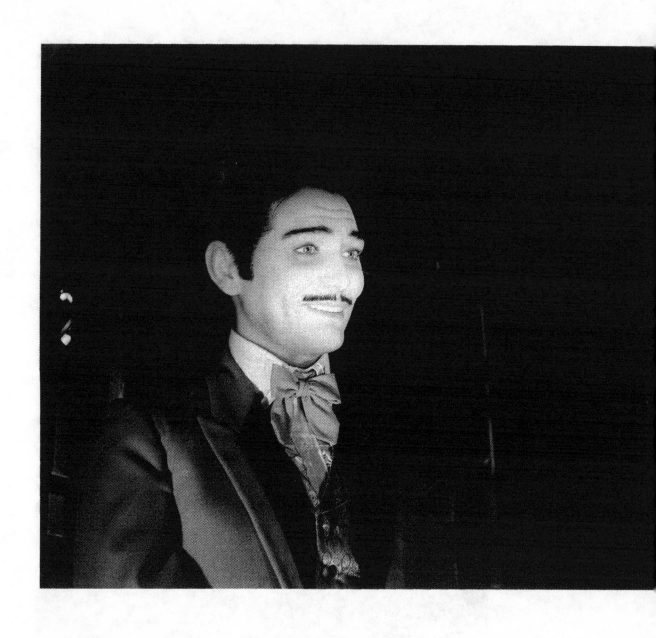

contd i must've gasped

what mask?

where?

you can't mean me

defences, rigged up fences

are quick t cover up one senses

when told

you're nothin but your mask

you are actin all the time

even when you're playin you

yes mama i'm an actor

the difference being my contradiction

that i

do not really wish t be remembered

for my smile

nor for my costume

but in complete reversal

as i look around

i realize

that i will be

ghost figures show no emotions

ancient sheriff's tie strangles

yet his eyes don't tell

a magic clown's body's

contd　being smothered in feathers

yet the dust on his mouth

dont even move

it seems like the

whole human race

is being insulted

makin my own disorder but wax of confusion

my longingness nothing but sexboard drama

my success, a neckful of taped together tickets

my blood lastin only in the crust of rapes ketchup

all of which will

evaporate

into the wind

yes, in true confession

i was startled wacked

wrecked off my feet

by fallin into

the frightenin smallness

of one's weary universe

touch me mama

it's all right

it doesn't matter

it's been too well proven

that even i, myself

am not really here

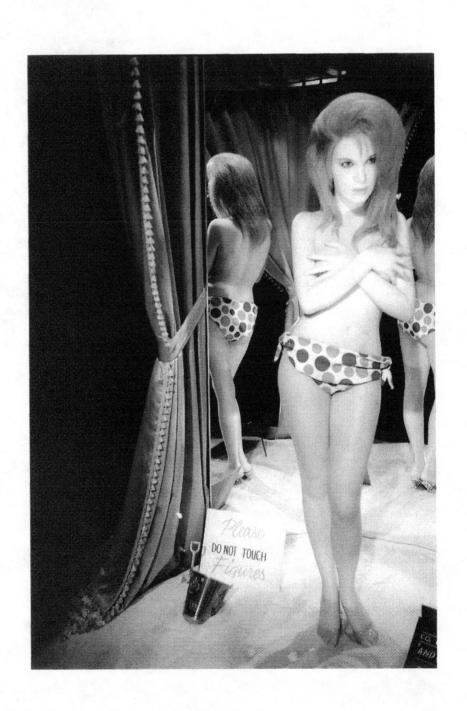

3

from the outside

lookin in

every finger wiggles

the doorway wears long pants

an slouches

no rejection

all's fair

in love and selection

but be careful, baby

of covered window affection

an don't forget

t bring cigarettes

for you might

just likely find

that one outside

leads farther out

an one inside

just leads t another

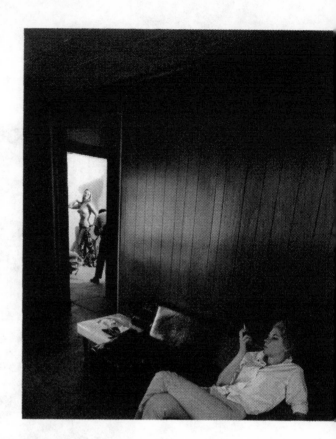

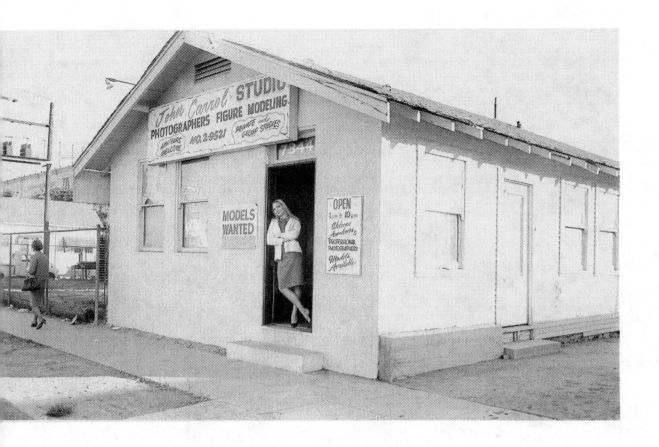

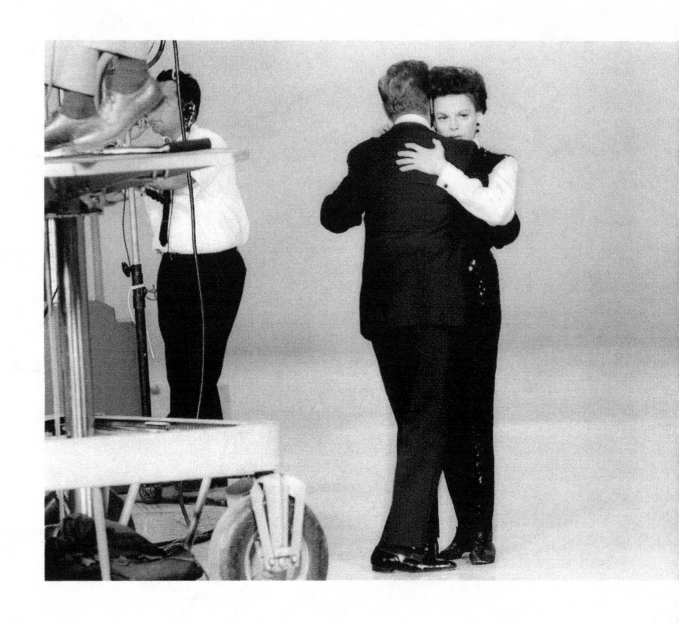

4

i didnt notice her

husband keepin track of me

for i was much too involved

watchin her

(her with the hand

about t grab her throat)

anyway it was when

he threw a rabbit punch

t my poor glassy chin

that i responded

"why'd you do that?"

"you looked like you werent takin her seriously."

"dont tell me you take her seriously?"

"you wanna nother punch?"

"did she really create the world in six days?"

"no one can talk about my wife like that."

"i think you aughta divorce her."

"you little know it all punk. she's my wife. she's beautiful."

"i'm afraid you're gonna have t punch me again."

"this time I'm gonna punch you thru the wall...then you

might learn some respect..."

knowing when i'm not wanted

i climbed out from behind the wall

an walked t the door

contd looked back

he still was starin at me

an she was still about t grab her throat

nothin had changed

"strange people at

your parties" i said

t the host

the host sat crosslegged

on a mantle

looked down at me

there were some

lights between us

she didnt say a word

14

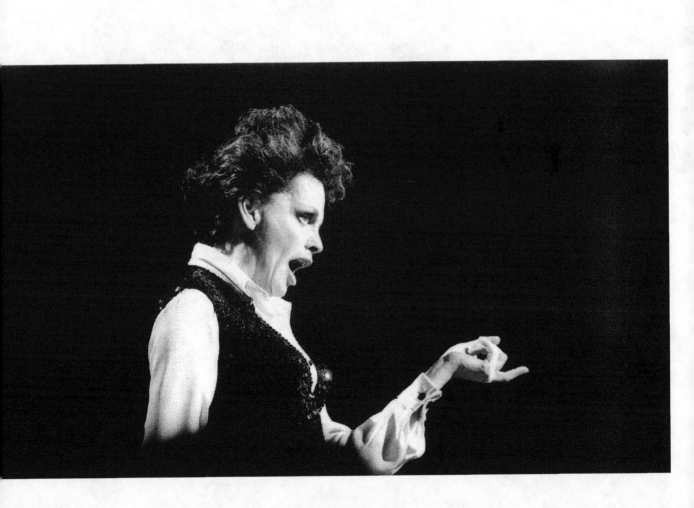

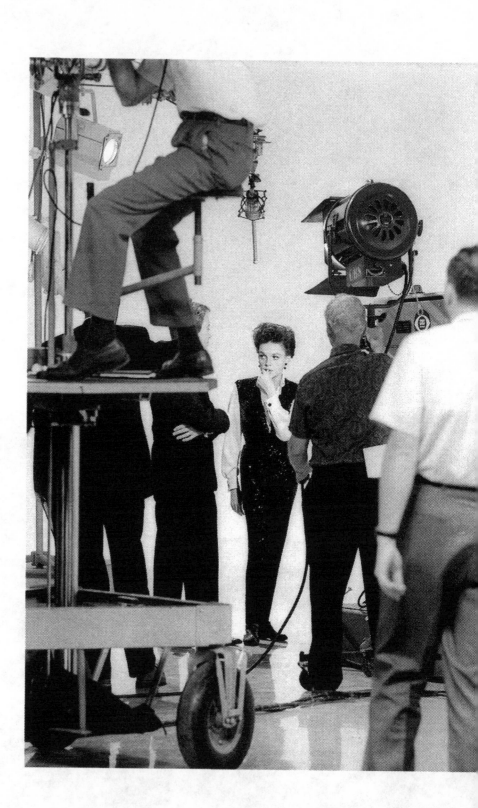

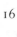

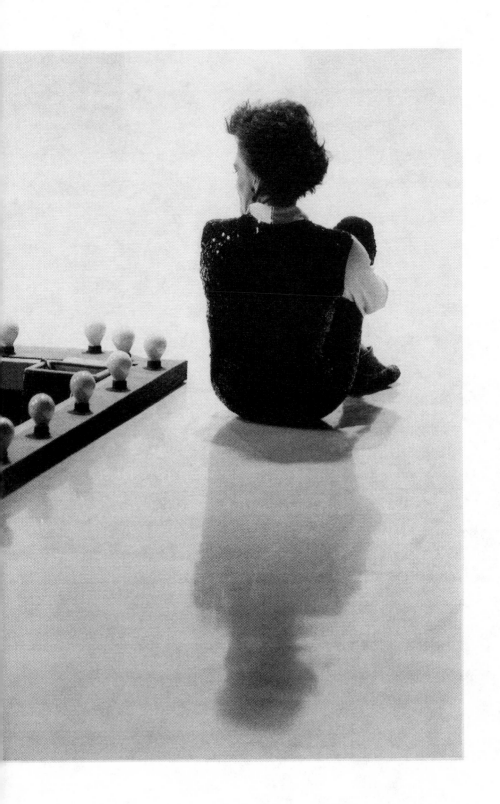

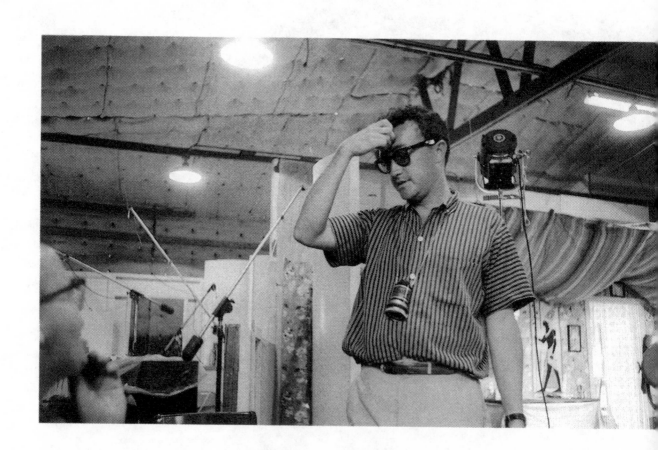

5

flag signs signals

handwaves

redlights

jump go

greenlights

switchlights

stoplights

all rights

not rights

no rights

this way

right way

any way

scratchin twitchin

itchin

that way

your way

contd time out time in

whirl whirl

spin spin

dizzy dizzy

busy

too busy

much too busy

very very

much too busy

t see the end

at the end

in the end

whole people

finish equal

an tho each tries

none dies

in cold flight

in sight

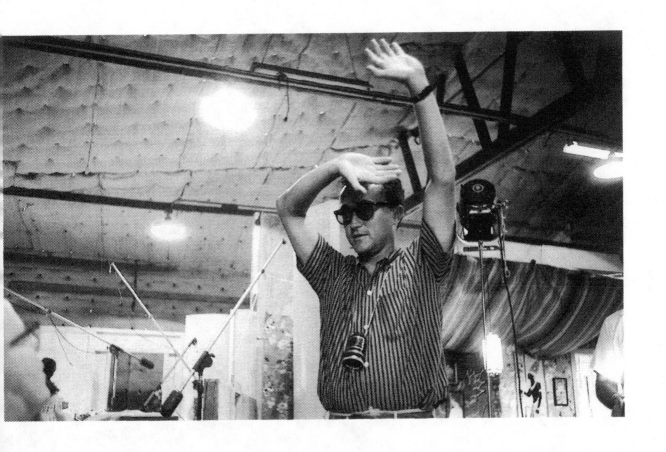

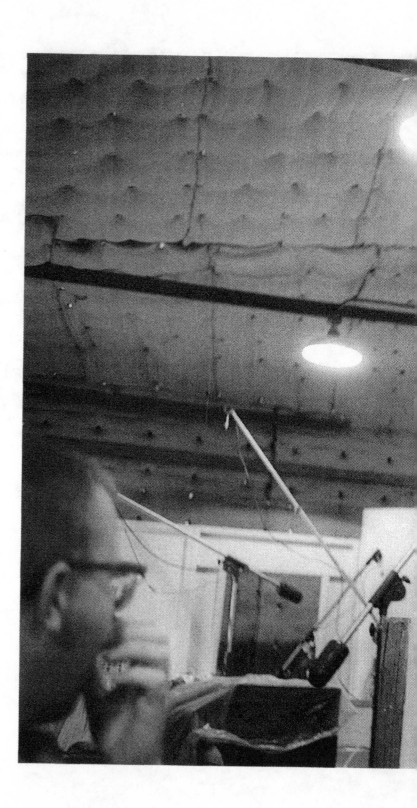

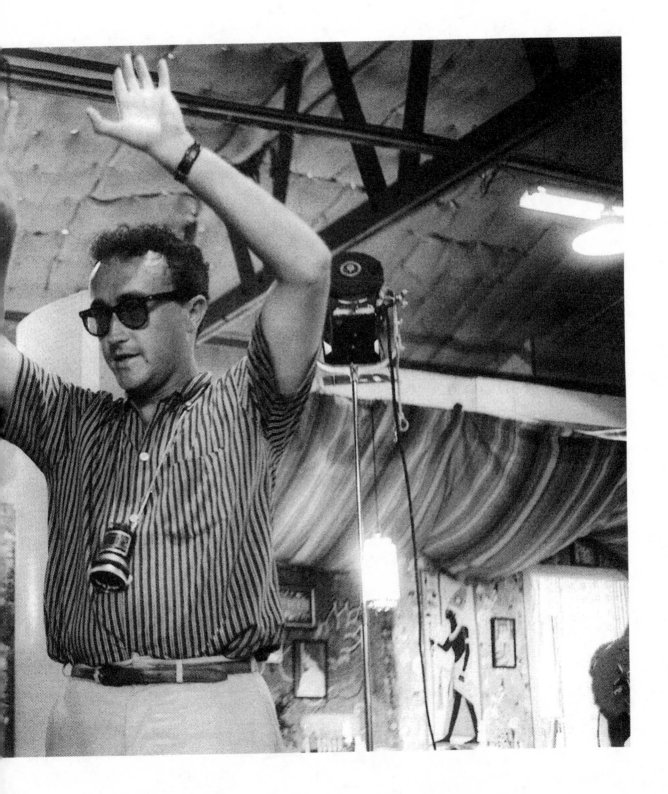

6

off my guard

dream's openin

catches fixed

favored first niters

furs reserved

perfume for the face preserved

important clutterers

ultra exclusive cost included

hooked an gathered

splendor feathered

spectacle respectable

with laps waitin

tender throated

then there's them

keyed out

on other side

careful not t get too close

t keep their feet

off sidewalk stars

dream bloops

two crowds

none survives

each thrives

off one it looks to

each will stand

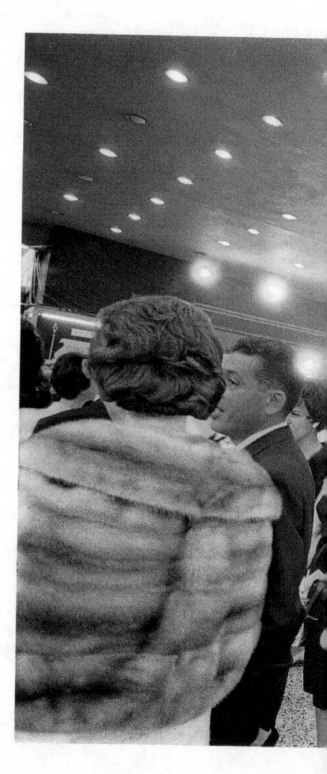

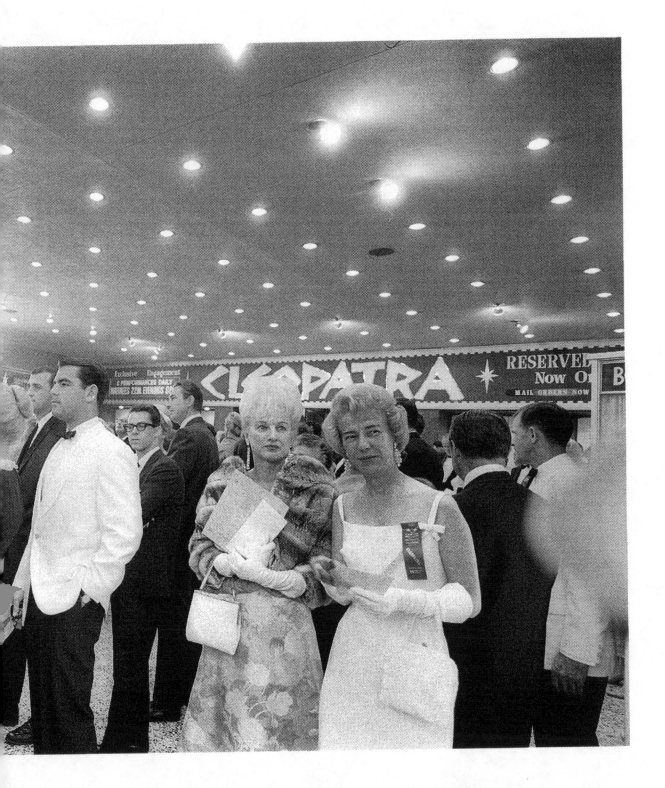

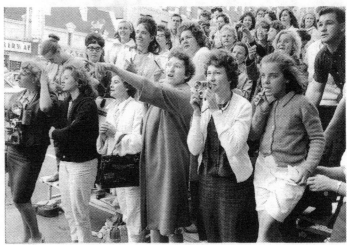

contd as long as other stands

both will die

at same time

each figure head

of each crowd

is capable

if he works at it

of switchin crowds

at any given hourly rate an

all figures

become one crowd

when a nitemare

is hatched

7

age shall guide thee

for a dollar down

youth shall lead thee

to a dollar up

darkness wears no face

corruption reeks

clicks its heels

dance around in the light

comes back t the shadows

hoppiddy

tip toes

untrained but feels

what it's taught

not t remember

seals, conceals

reveals

all at same unrestrained

slow motion speed

what it

memorizes t forget

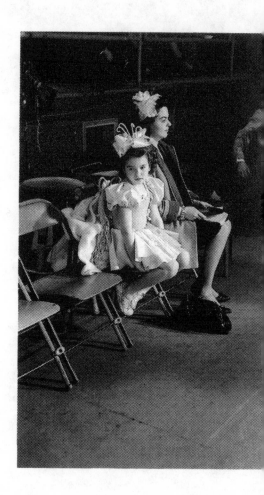

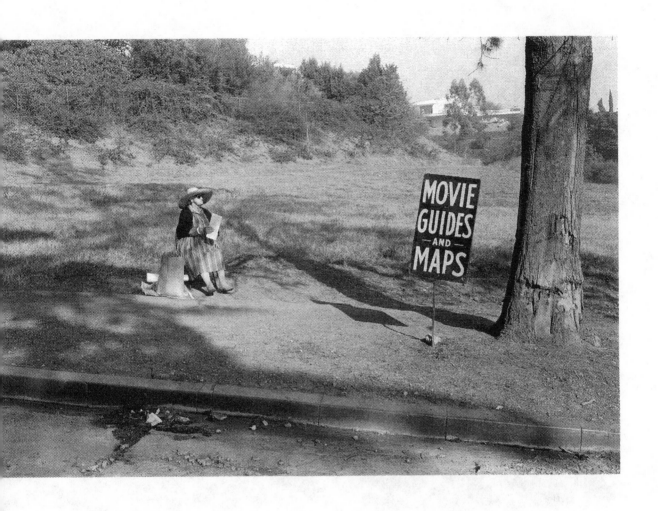

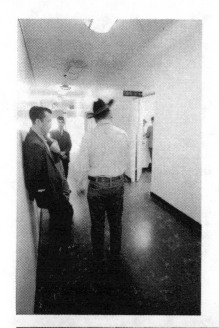

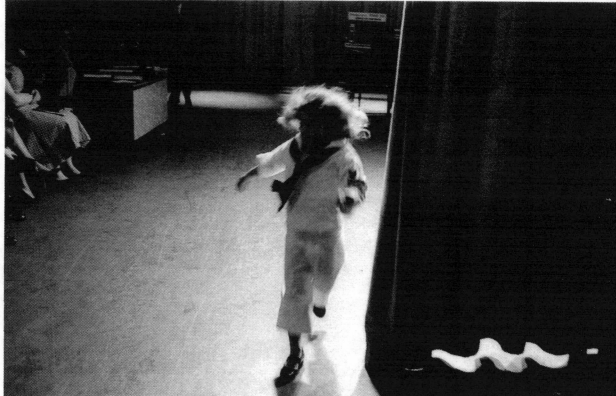

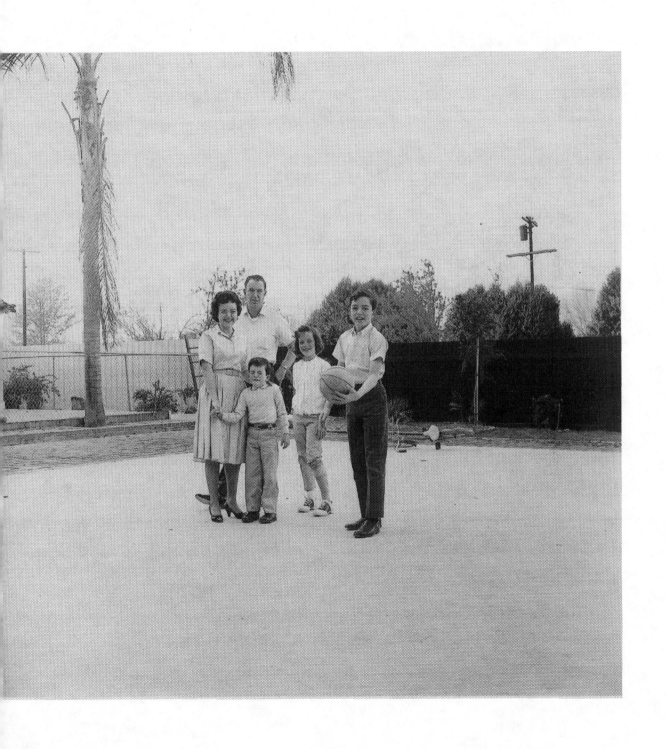

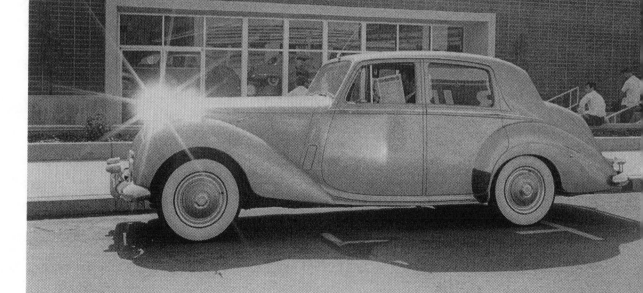

8

i was very sick one day

with an infection in my ear

so i went down an

grabbed some blue shield

an made it t my private hospital

as i waited in the corridors

i could tell that my doctor

was all filled up for the day

i got back in my car

but there was a strange figure

on the dashboard

as i looked closer,

it was a jeweled goose

an it shouted "gobble gobble" at me

i said

"dont you know where i'm from?"

she got mad an swore at me

i jumped out a the car

ran down the street,

lights blinding

a telephone pole blocked my path

an i suddenly came t the realization

that there was

no place t go

but up

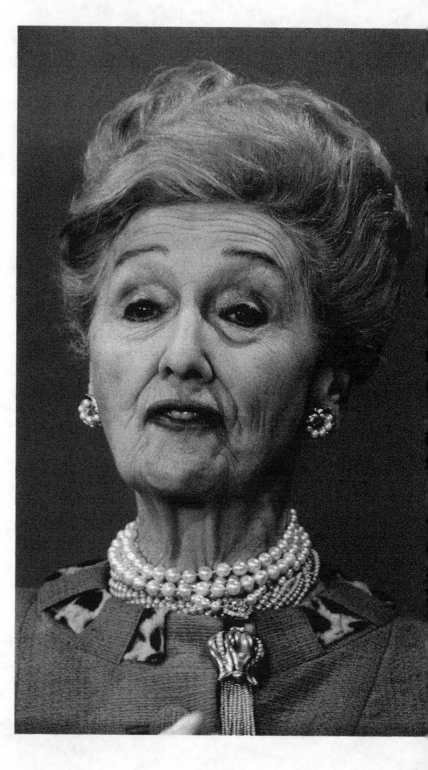

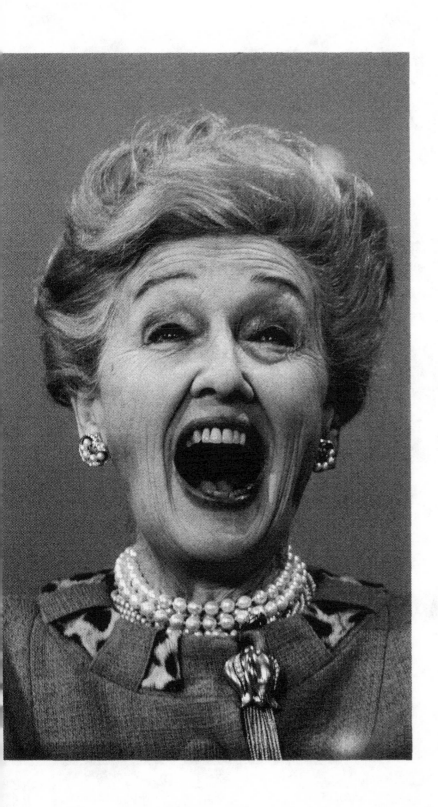

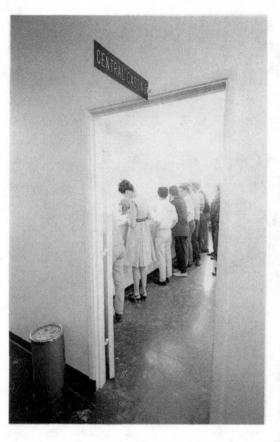

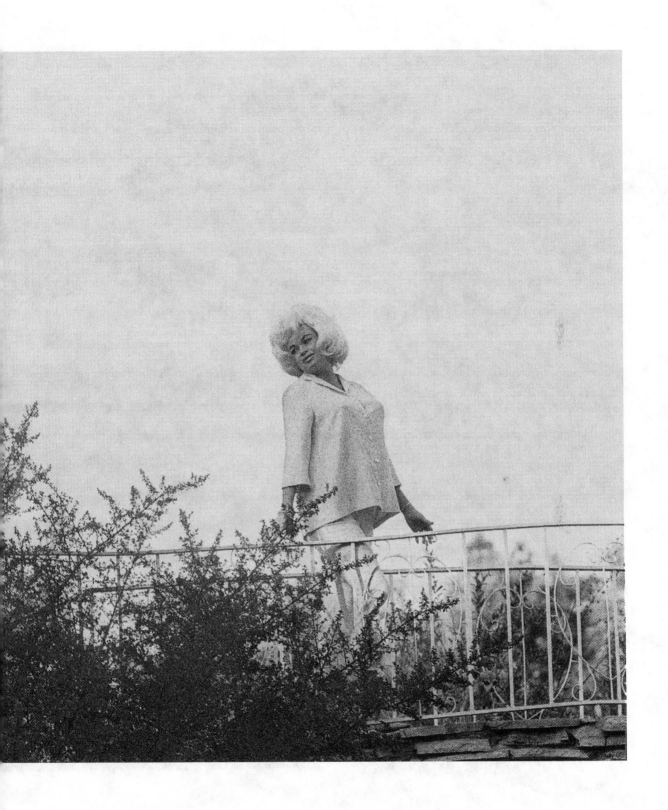

9

t be born with choice

t be carried free

out of cradled touch

clothed completely

in rapid change

no ties

suitcase

no chain

weighs arm

drops down

needs rest

go find

if all's true that calls t you

me suspended

ok

i'll come

show me how

i'll knock

rap tap

crystal door

knobs none

no creaks

hollow inner sanctum speaks

keep comin

right on in

contd follow down

love you

walk thru

you're welcome too

t bring pack

never says

how i'll get back

space droops lifts

air shifts

foreign land

end of road is out of hand

offers now not what it gives

but rather dont

get in too deep

bout what it wont

laughin matters

pull joints

t detour

sidestepped

a slave t see now

what's being kept

hands pull

brace floor

red light door

grunt groan

first sign

43

contd someone's lyin

sneak around

garbage pile

find out

it's just a mile

feel better

good t know

i'm not a quitter

sun's hot

i'm not

wont cease

just go

dont care

whatever it is

it's waitin there

on lease

get piece

sucked in

on a habit

gotta have it

promised by

the prostitute

destroyed ruins

tilt the day

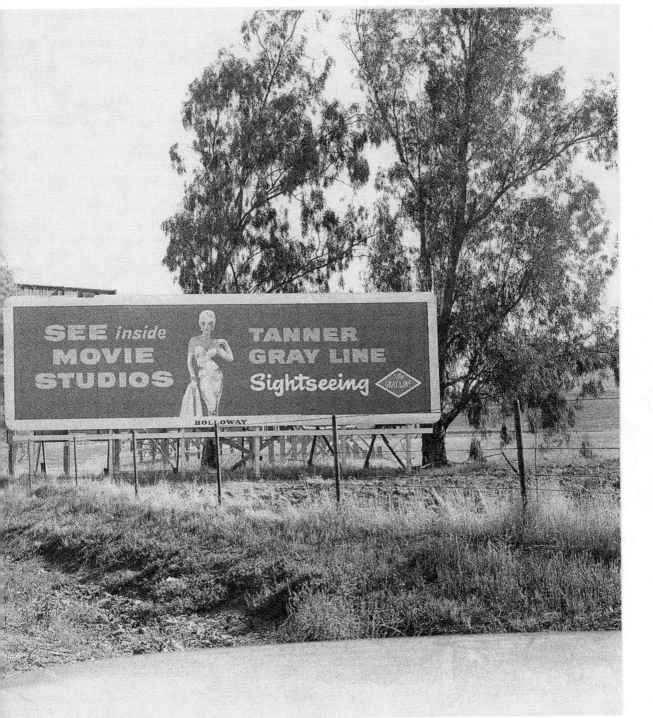

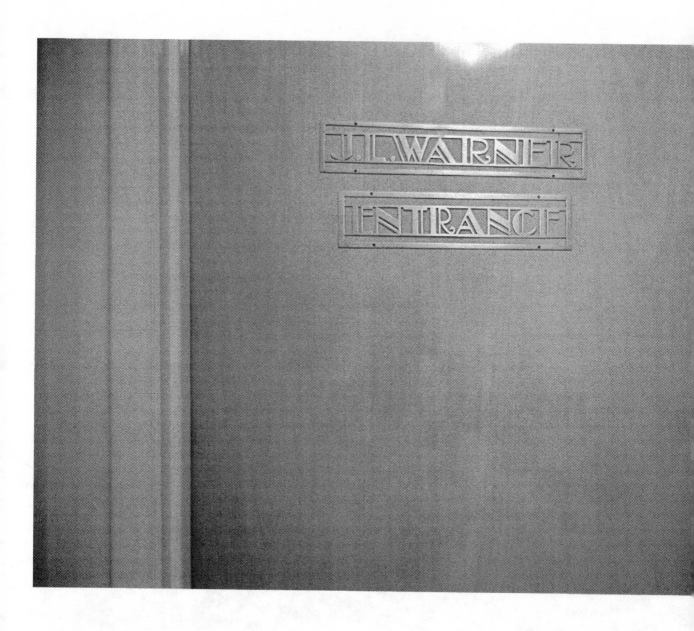

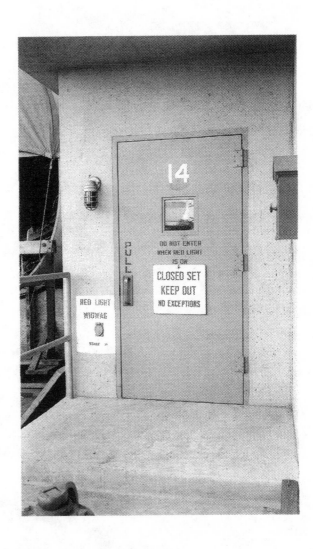

contd revenge bursts

guts decay

rats play

uppidy up

jellied into gangreen

unseen

looks clean

brothers' guns

mother's sons

blast credits

proud

own prizes

pound chests

congratulations

proud?

me? i'm ashamed

ashamed t know

just who's t blame

starving people

could eat awhile

on what this

nonsense represents

presidents

dont cry

so why should i

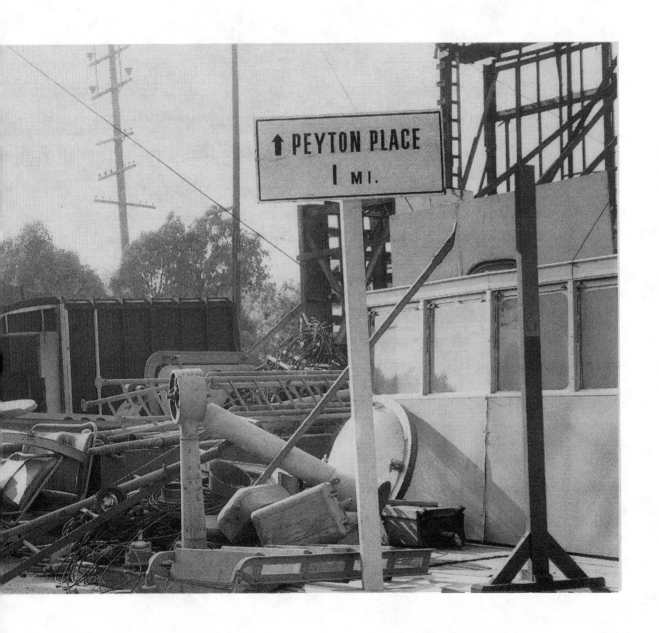

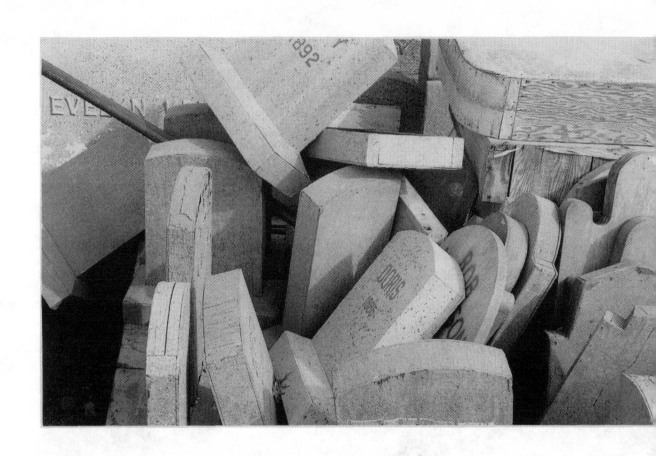

contd off an runnin

runner up

bound t go

bust the top

just t find out

what i'm missin

an as morons take winks

seriously

back at the beginning

i crawl into pillars

double jump headstones

pretendin i know

nothin about

the last

vanishing

staircase climb

confident my final finish

will see me

before i

see it

nothin matters

it could be nite

or it could be day

it's hard t tell

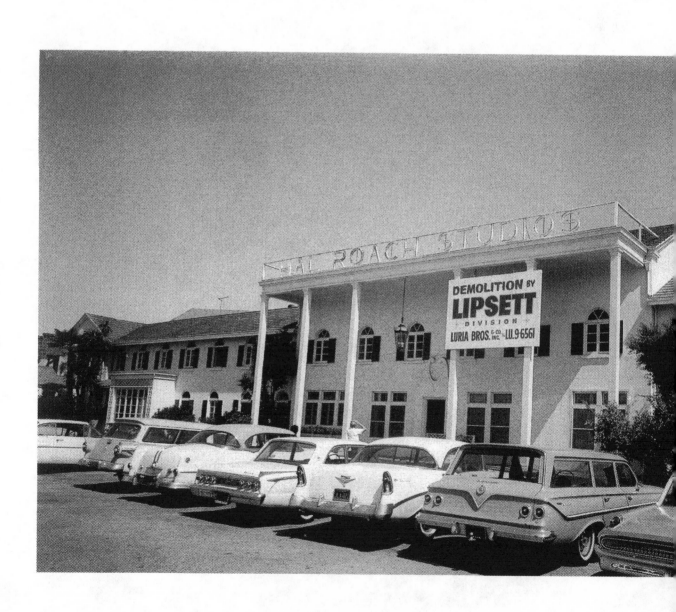

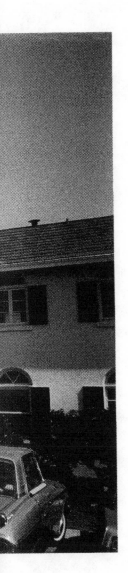

contd it's hard t say

with any notion

any breath

if even great

almighty death

is such

a long way down

t travel

endless fall

if religion

rides its depths at all

if it's so different

then this last hype

dodgeless

dodgeless

once in fashion

if the fruit of heaven's

really ripe

if it's as long

a journey

as the one i

just went thru

after reachin

standing

resting

at the peak

53

contd at the tip's point of the peak

at the weary uncalled for peak

at the top

at the eclipse top

at the uninhibited throne

of someone's

triple breasted kingdom

going

going

gone

an never no more

returnin back

54

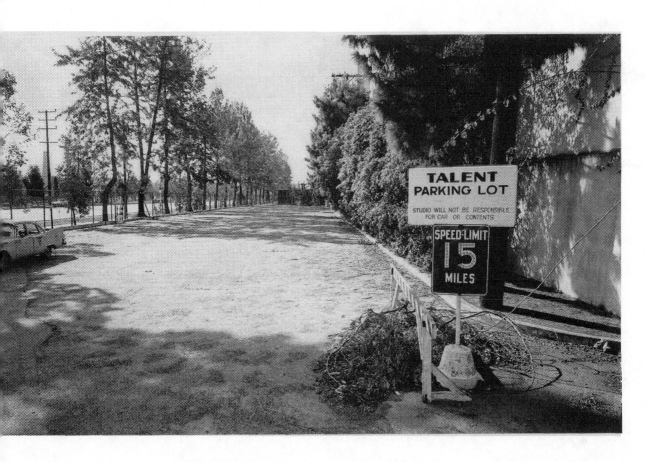

how do you think i'd be?

i don't know miss, uh…uh what did you say your name

was?

conny rainbow

uh yes miss rainbow. well i dont know

perhaps you could stop shakin your hand

how's that?

yes that's good miss rainbow

but do you think you could take it

off your nose an remove your hat an coat please.

surely how's this?

Very good miss rainbow

very good indeed

but what i think i had in mind

was a little younger type

an also a little more Ann Frankish

how's this?

Very Very good miss rainbow

you sure have talent

now let me see….

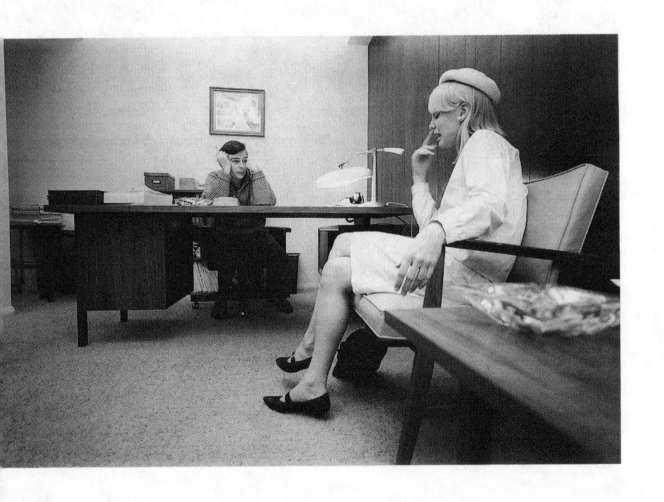

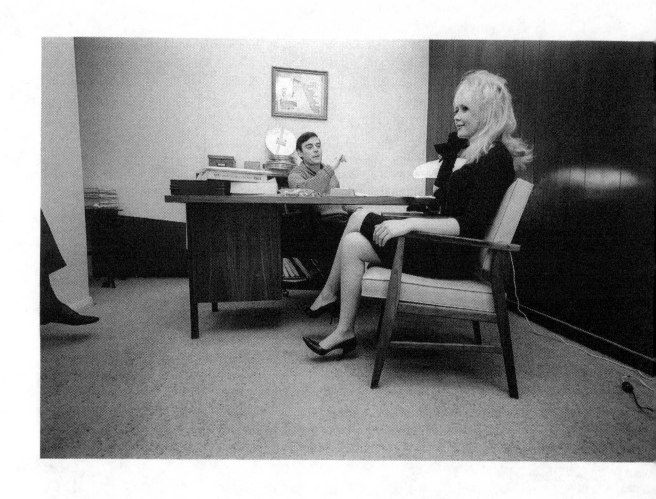

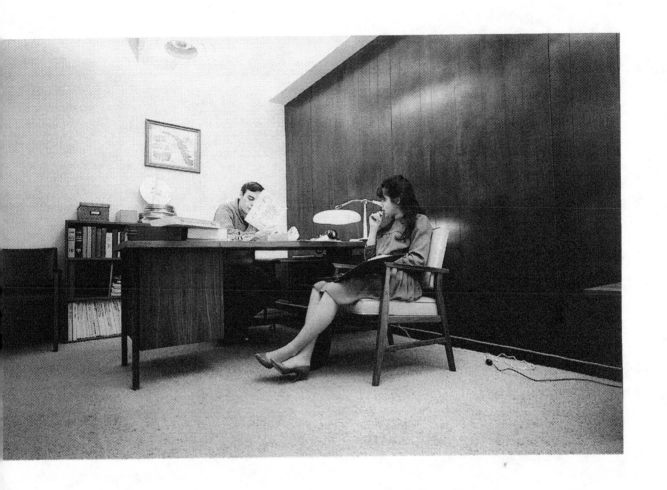

11

he came by the house

he said he knew friends

he didnt ask many questions

he said he was hungry

we gave him food

he talked a lot about the many of them

an the so few of us

he said he was thirsty

we gave him something t drink

he talked ideas on world affairs

said the race situation

disturbed him deeply

an spoke of europe

told of a place

that was peaceful

quiet

nobody hounds you

groovy people

can do what you want

nobody takes notice

good place t paint

he thanked us for everything

smiled politely

said if ever we needed him

just let him know

contd then took the address
said he would write
he closed the door gently
vanished quietly

havent seen him since
but right after he left
strange things started t happen

contd we stare out the back windows now

an aunt samantha asks each time she comes

62 why the doorbell's disconnected

the record played "stranger blues" when we came

now it plays Vivaldi

an the rolling stones

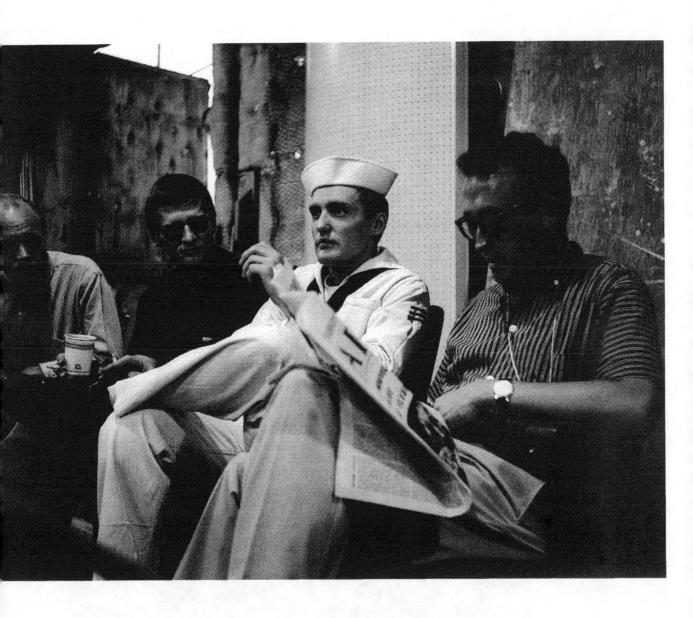

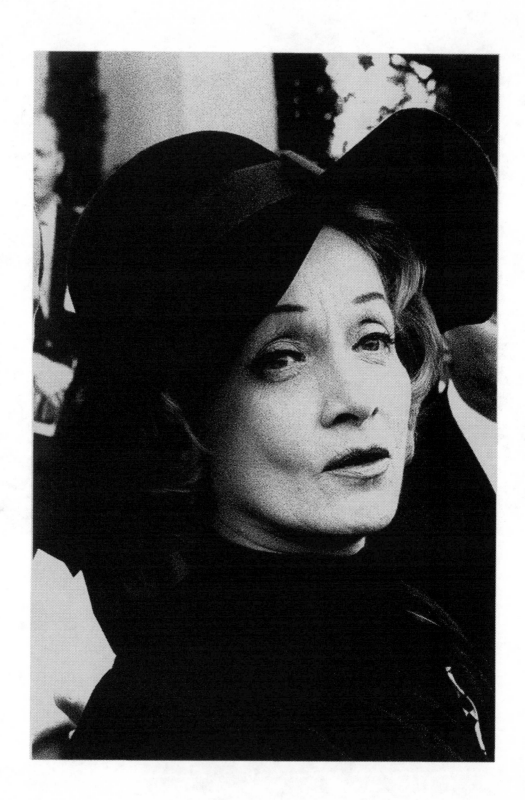

12

t dare not ask your sculpturer's name

with glance back hooked, time's hinges halt

as curiosity's doom inks beauty's claim

that sad-eyed he shall turn t salt

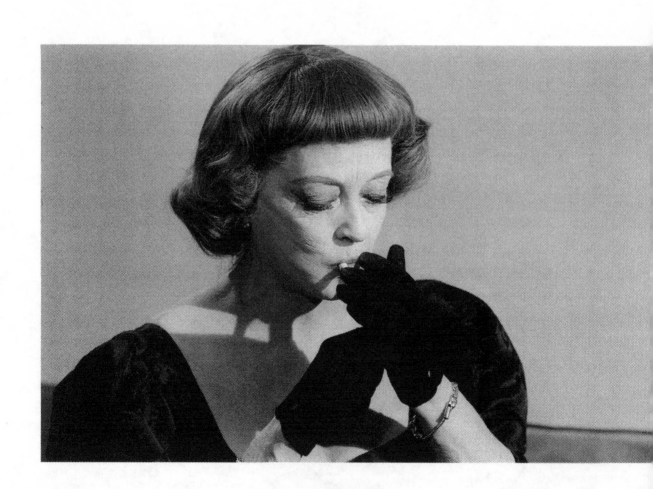

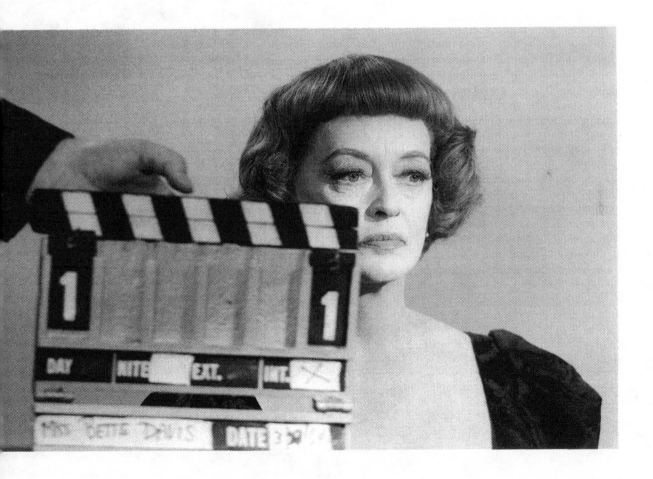

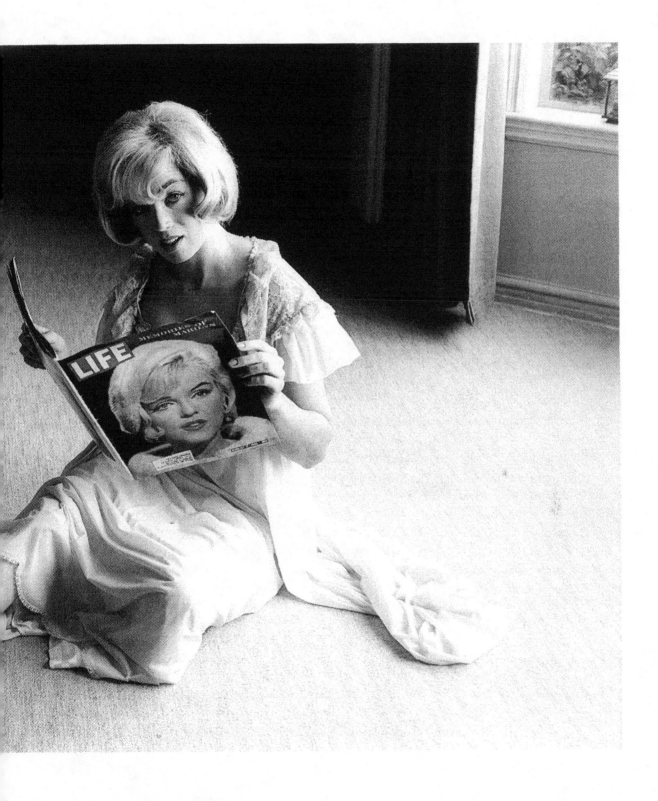

13

voice of authority

all right now, supposin that you've just received
a telegram explainin that your husband has
been eaten by a boa constrictor after the atomic
bomb has just fallen in new jersey...now how would
you react in such an instance?

like this?

voice of authority

yes. ok. that's fine but could you show a little more
restraint please. i'd like the point t come across
that you hurt. your husband died in agony. you're
sufferin. you begin t sweat. could you
show me how you'd do this please

like this?

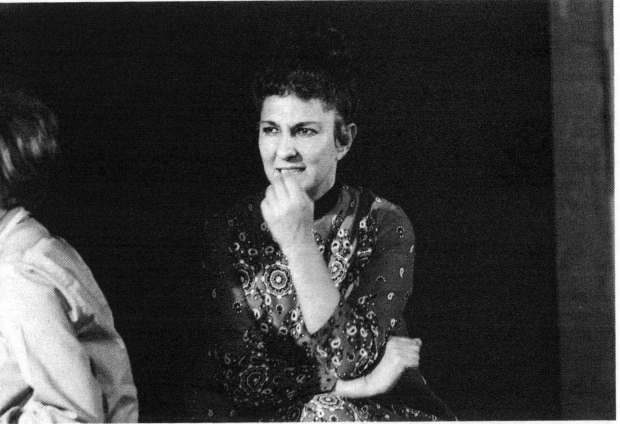

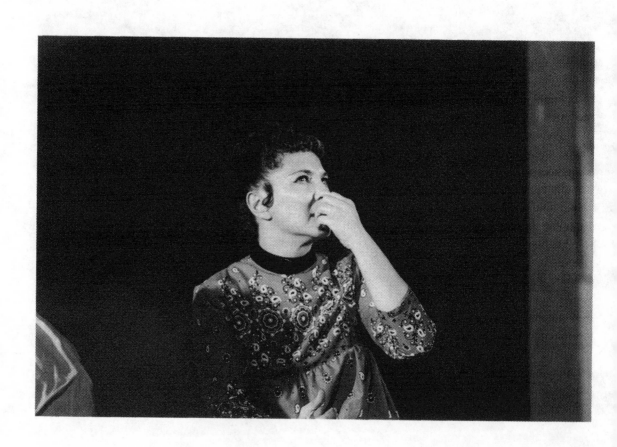

contd fine. now supposing another telegram comes an says that
they killed the snake. that they bombed him as he was
headin for the lincoln tunnel. you're a little happier
now but still you cant get over the feeling that you
wouldve like t've done it yourself an also you're
a little perturbed over the fact that all parts of
your husband are lost. right now, you could really
use a shoulder t lean on. now i'd like t see how you'd
react in this case

like this?

yes...well ok thank you
dont call us
we'll call you

73

"i betcha a dollar that there's something funny the matter with
the president"

"something the matter with him?"

"something funny"

"why d yuh say that?"

"well look, cant you see he's pointin t something?"

"yes yes uh huh what about it?"

"yeah but his eyes're closed"

"his eyes're closed! oh my gawd! they are. well…i uh i don't
see anything wrong with that. uh perhaps he's sleepin"

"sleepin!"

"yes. not so hard t figure out. everybody goes t sleep you know"

"yeah but what about his hand? what's he pointin at?"

"hummmm gee i never thought about it. pretty strange…maybe
he's just dozin an you know there's probably lot of pressure
on him t be doing something all the time"

"yeah well he's not even thinkin about anything in his head
an there he is with his hand stuck out like he was givin some
kind of orders about something else that he's not even pointing
at t begin with…i mean like what does it take t think something
funny about something?"

"well…well i wouldnt call that funny. i wouldnt call that
funny at all. he's probably in that position so people wont
think he's asleep"

"he's coverin up"

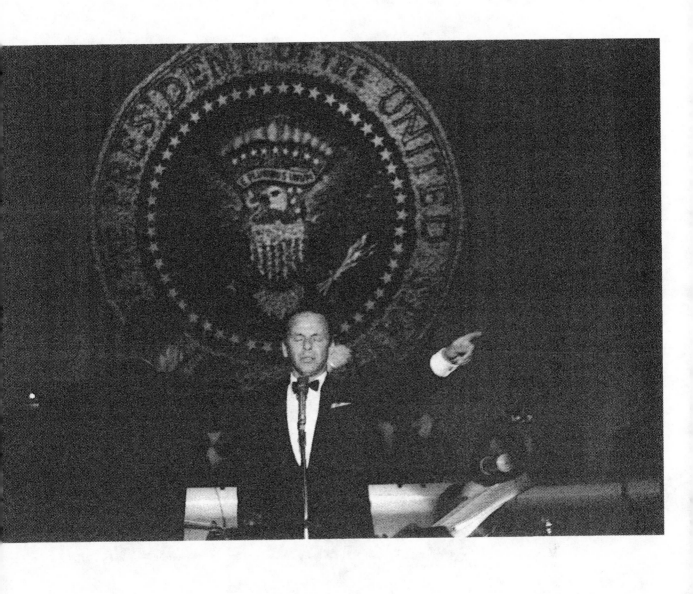

"he's dreamin"

"he's dreamin?"

"yeah an i dont see what's so funny about dreamin. lot a people

dream"

"oh man, but it looks so weird"

"i dont think it looks weird. an anyway, what if he's havin

a nitemare?"

"what about it"

"well then dont you think we aughta be nice t him. be quiet.

show him that we care. pretend not t see him?"

"you mean get behind him. help him out"

"yeah"

"yeah but he's not doin anything"

"well what d yuh think we aughta do then?"

"we could wake him up t begin with…"

"hey hey come on come on what're you talking about?"

"what's who talkin about?"

"you! what d yuh mean wake him up? you off your nut or somethin?"

"off my nut?"

"yeah, you off your nut, he's the president you idiot."

"the president? you'd think he was some kind of movie star

the way you talk about him"

"i'm just more civilized than you, that's all"

"well i think he aughta be woken up"

"how dare you"

contd　　　"i think somethin's funny with him"

"you're a maniac"

"well look at him. all you gotta do is look at him"

"you're outa your mind. you're probably a cuban. Gimme the dollar"

"but look at 'm. aint cha lookin at him. cantcha see him?"

"no…no i cant. gimme the dollar"

15

each lonesome soul

(on chance an not choice)

honors moans of lost silence

(locked pregnant voice)

by freezin in kingdoms

dejestered, unthroned

weaved by the spiders

who've abandoned. disboned.

in wombs of soft poverty

subprivate unblessed

the mystics wait

but couldnt care less

paint mist colored keyholes

all candles pale

drain all lined distinction

among man an female

melt down into ashes

all shading of skin

breedin any saint's smile

with a young orphan's grin

swallows religion

all attitudes

turns armored masked bandits

into stark naked nudes

contd an with tinglin quiet

touches its raped

as the wind touches tree limbs

the sky, no escape

counts the dead sheep

piles them in herbs

into phantoms of dust

an scatters their nerves

back out the great pigeon hole

beyond the divide

with a smooth single rope

t heal its untied

constantly confident

the enemy's none

knowing well that its number

of souls so undone

indeed without countin

add only t one

79

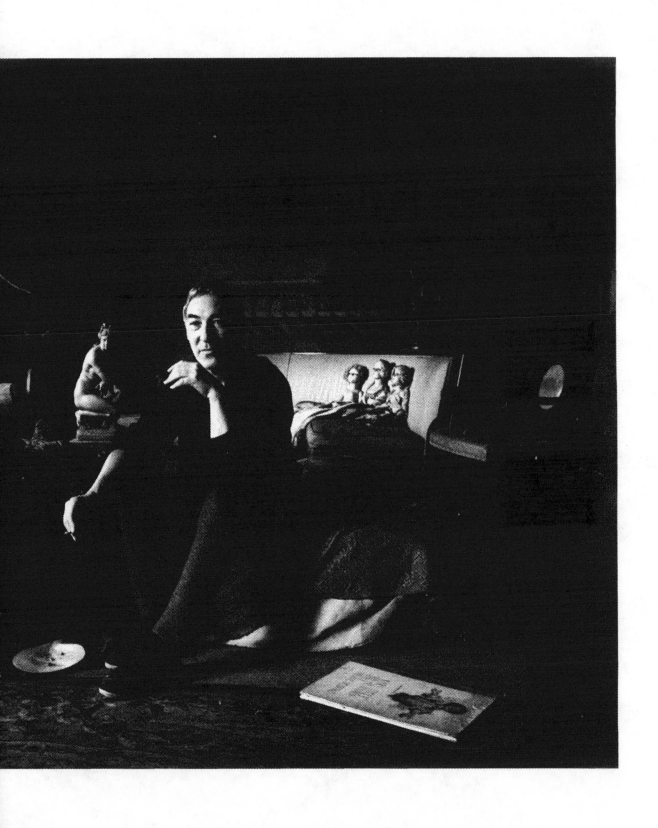

16

i found me in a box

ripped it open

put myself on

everyone else

did the same

i could see them all

i could peg them all

just by the sight

of their box's name

until one day

i abruptly discovered

that all of them

could do the same

"i think we're foolin

each other" said me

"why dont we take off

our clothes an see?"

lots listened

some applauded

all talked

one day i came back

an found the word

idiot scrawled across

my box

my feelings were hurt

contd i close my eyes

got lost

dove into cardboard

drowned into paper

watchin wrappings

whirlin by

up an down

in an out

til i found myself

with the rest

of the dummies

who also know

if nothin else

that nakedness

cannot be covered

by a name

an we hardly ever

have t speak

for we dont

call

each other anything

84

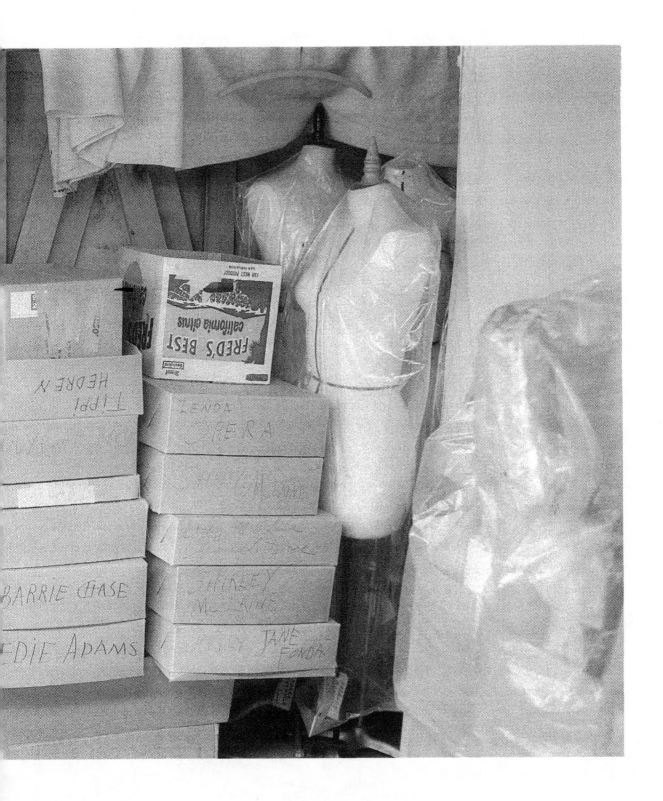

17

after crashin the sportscar

into the chandelier

i ran out t the phone booth

made a call t my wife. she wasnt home.

i panicked. i called up my best friend

but the line was busy

then i went t a party but couldnt find a chair

somebody wiped their feet on me

so i decided t leave

i felt awful. my mouth was puckered.

arms were stickin thru my neck

my stomach was stuffed an bloated

dogs licked my face

people stared at me an said

"what's wrong with you?"

passin two successful friends of mine

i stopped t talk.

they knew i was feelin bad

an gave me some pills

i went home an began writin

a suicide note

it was then that i saw

that crowd comin down

the street

i really have nothing

against

marlon brando

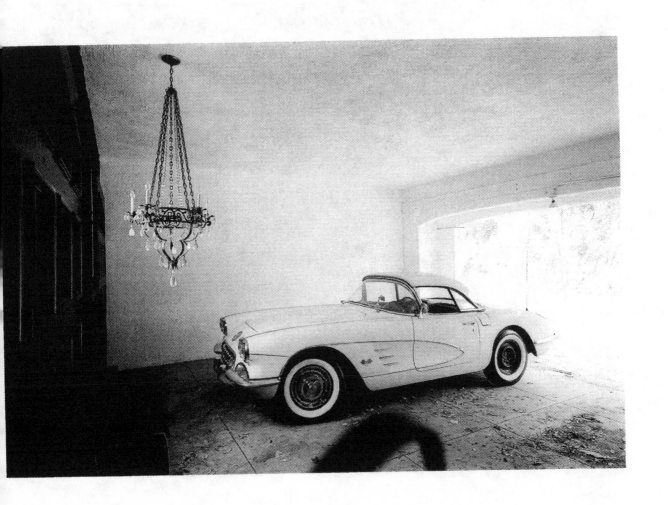

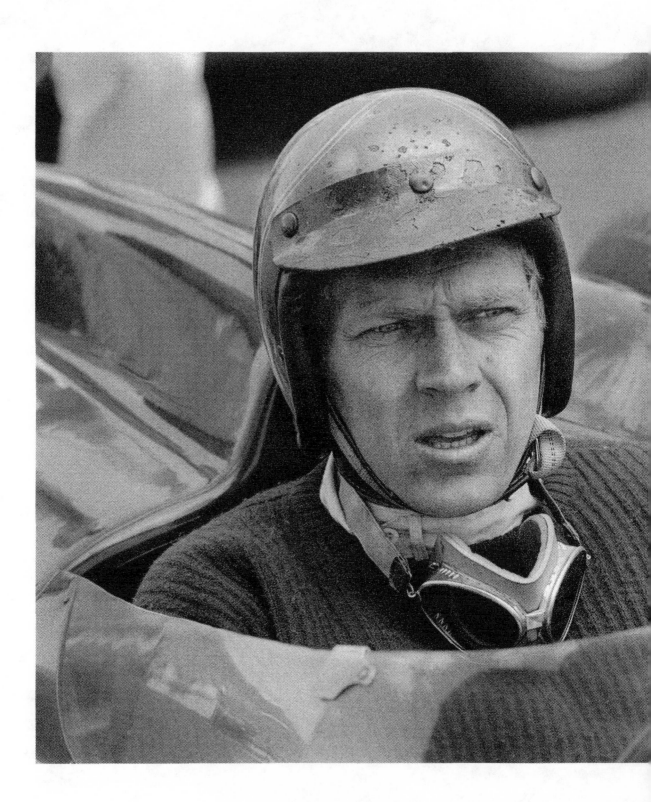

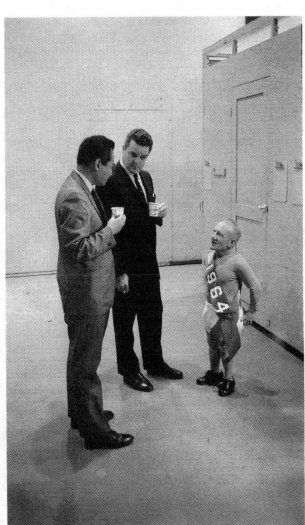

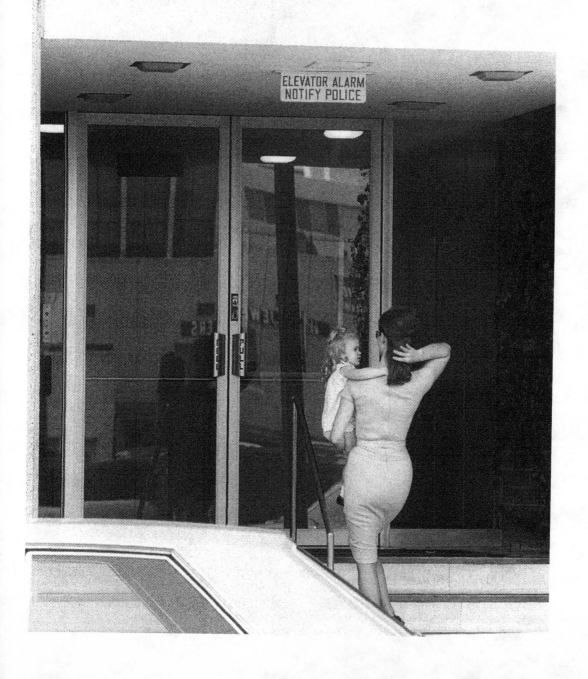

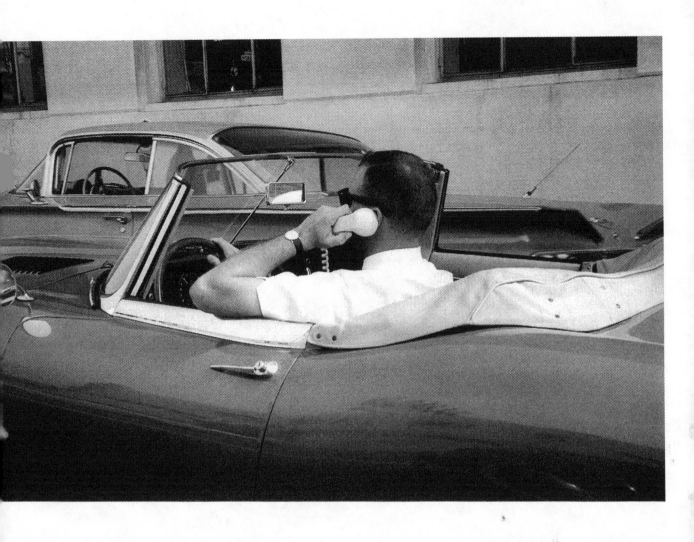

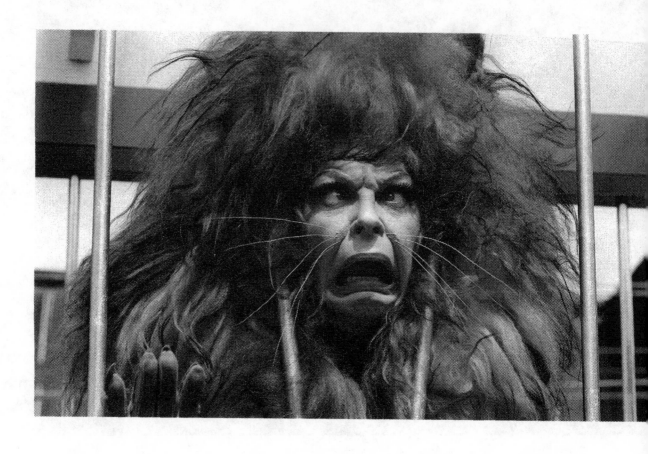

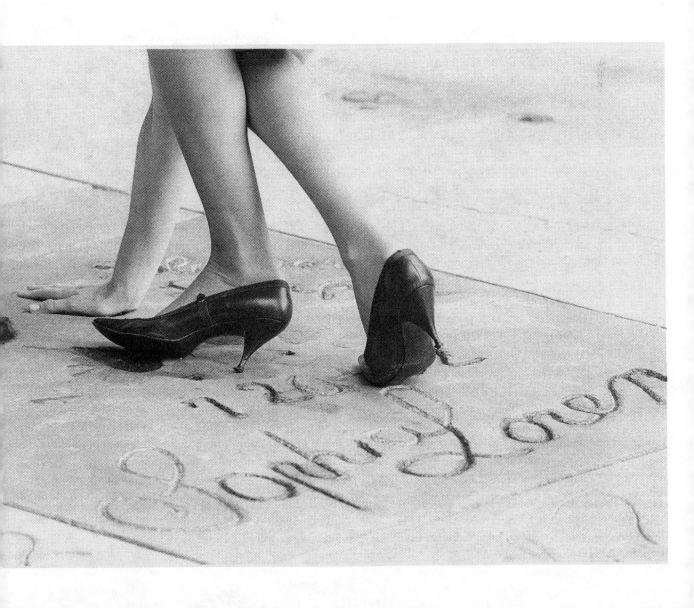

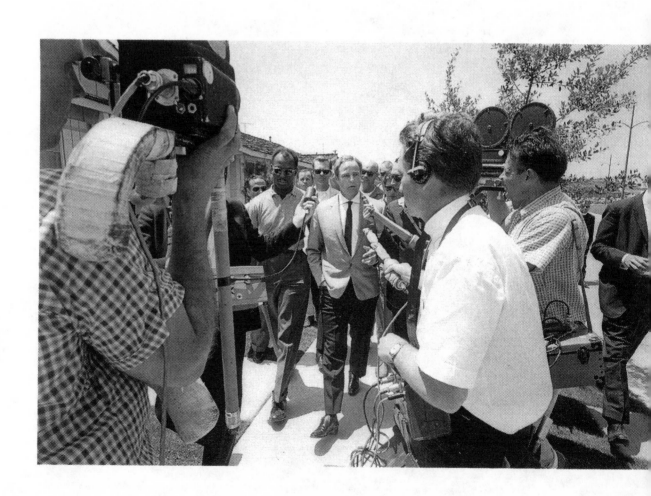

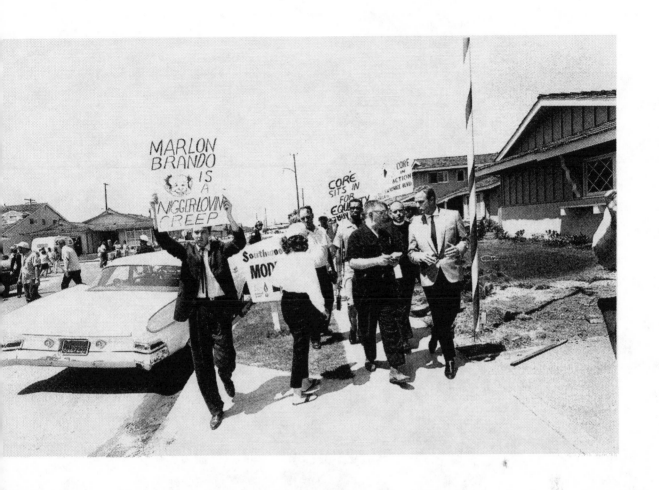

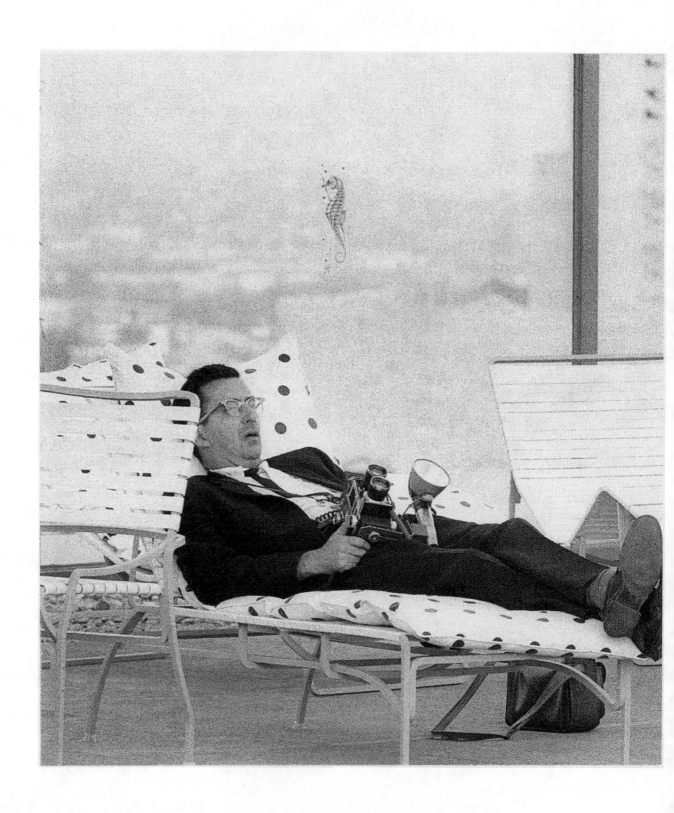

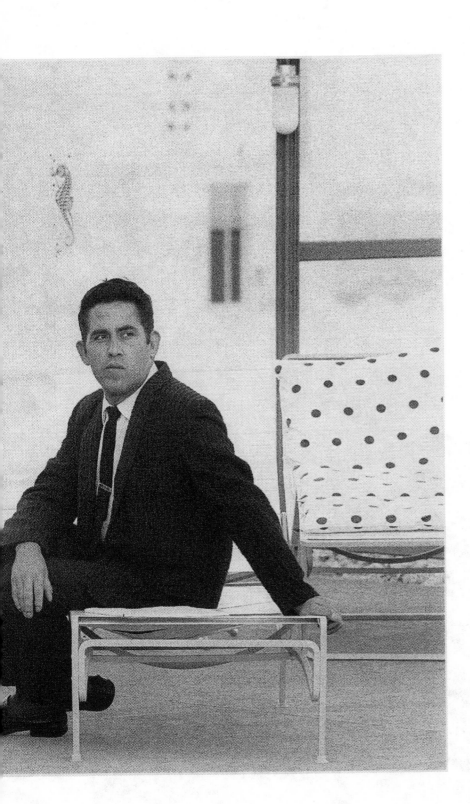

99

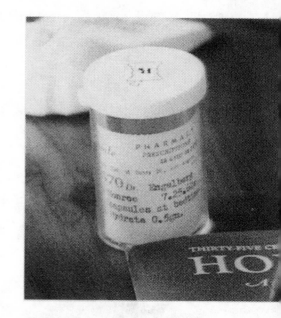

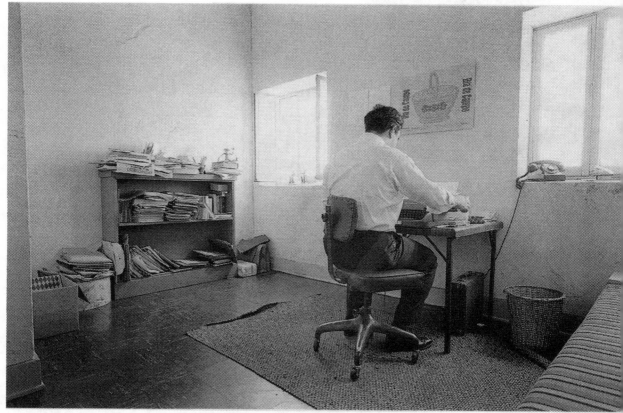

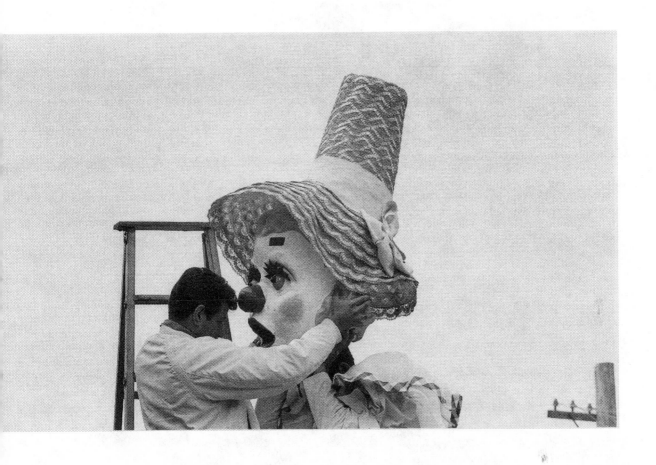

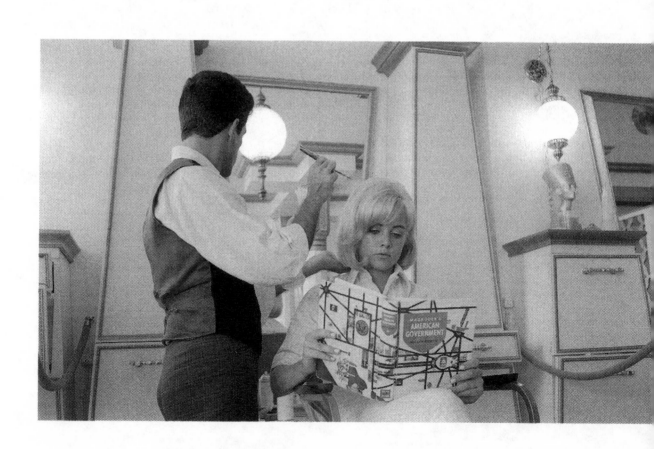

18

neatly sweetly

boy meets girl

cokes t coax

sit there an sip

young love

yummy first

something in common

blunt cuteness

of nothing's wrong

we'll work it out

smooth as a gull

being recorded

happy ever after

while extras

wait above the set

an lolita reads

toilet paper

while prayin

in her favorite church

19

blindly i wake

stagger t the window

yawn

truth stands perched on a hill

must be my day, mama

i stick my elbows

on the ledge

stare at it

get dressed

keep eyes on it

gonna get it

probably

wont get chance tomorrow

off off

out the door

it looks so real

from far away

the only things

that's real i say

me

poor me

i follow

go higher

get tired

had hunch t bring lunch

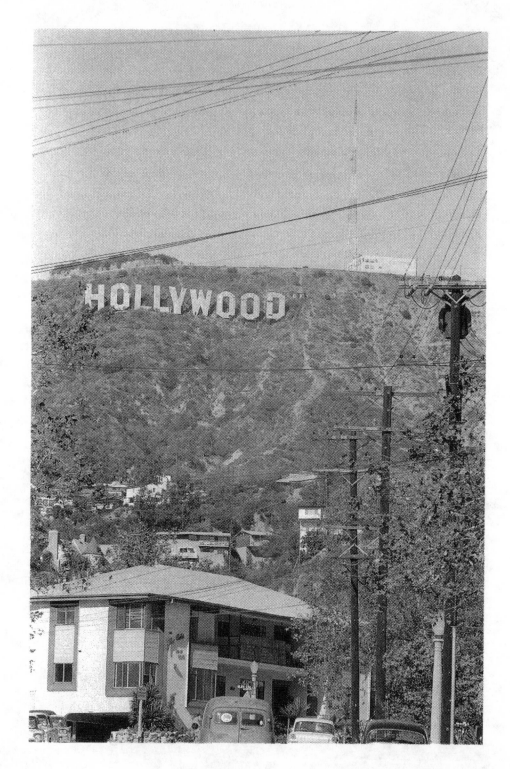

contd rest stop

under wires

pin my eyes

the same truth

it's closer now

but looks the same

higher high

an we're neath the sun

eyespan bigger

stand in front

it's all spread out

completely simple

face the truth

there it squats

a million watts

strong an shinin

we go searchin

onward onward

when you get closer

you get smarter

we always say

upward up

in the early day

get it get it

107

contd wait'll i tell

my friends about it

that i got it

maybe i'll own it

then loan it

on no

oh my gawd

it broke apart

how awd

unyieldin truth

has spattered up?

i cant believe it

who went wrong

it cant be true

it's much too big

cant even see

it all at once

so close before

was gonna grab it all

it's getting nearer i know

now it's broke

must be some horrendous joke

i walk along

giant particles

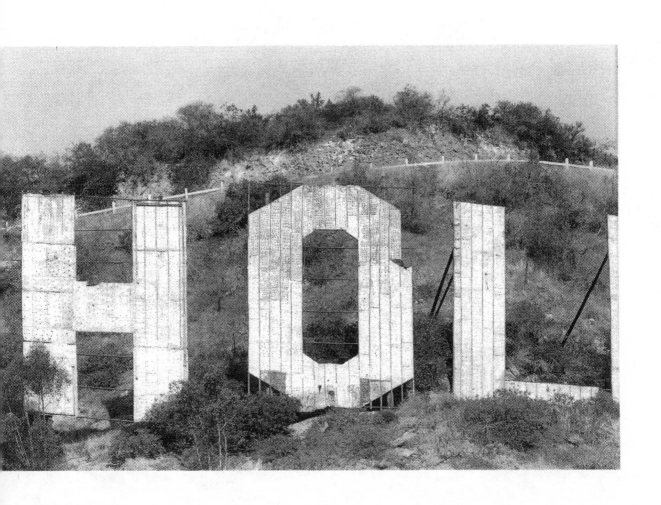

contd huummmm

very complicated

all of a sudden

i cant make out

what each piece of

it looks like

grime rolls in it

there's holes in it

dont make no sense

almost embarrassing

can see its cracks

confusing

is this the alpowerful truth

that looked so easy t see

from far away?

the one i started walkin towards?

the one they told me about?

if so,

then i can even

see

what holds each part of it

up

an i, mama,

am no

genius

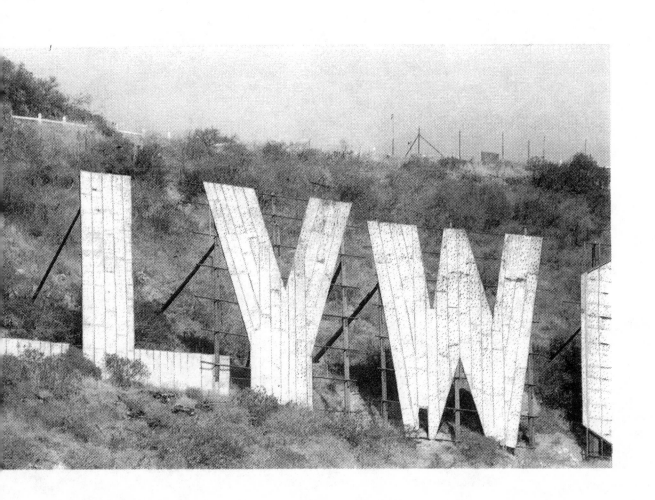

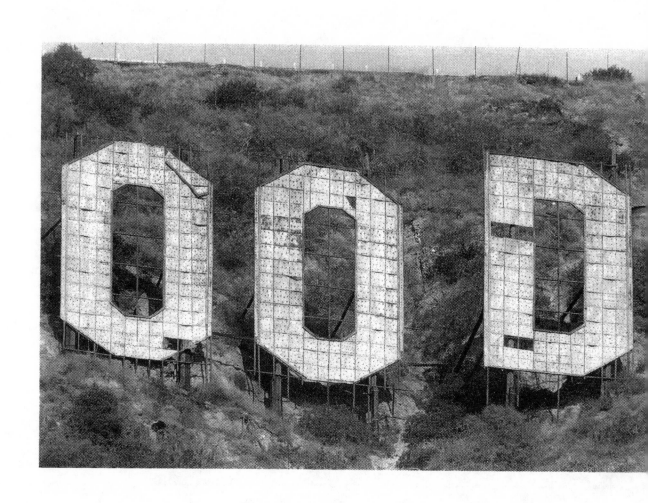

contd off again

away away

go right thru it

make room for the others

comin to it

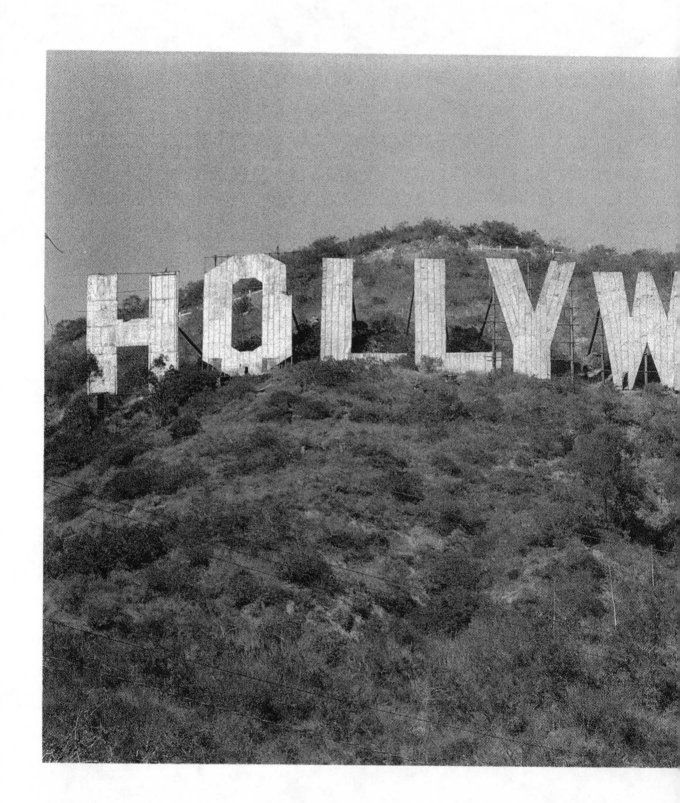

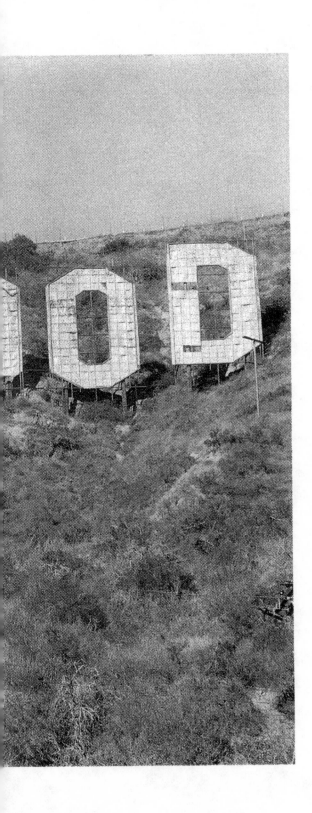

115

20

jaundiced coloured girls

pop out of nowhere

offerin roses

cant eat your roses

get 'm out of here

gimme food

i dig food

cant swallow the smell

of your flowers, lady

want turkey buns

hamburger meat

history gets the hungries

an even the witches

sometimes have t eat

so please pardon me

an dont think i'm prejudiced

if i pour your drink

all the way down

your hairlip gown

there's nothing t be

disturbed about

it's just that

there's enough people

bending over

with the fangs

of society

burnt into their backs

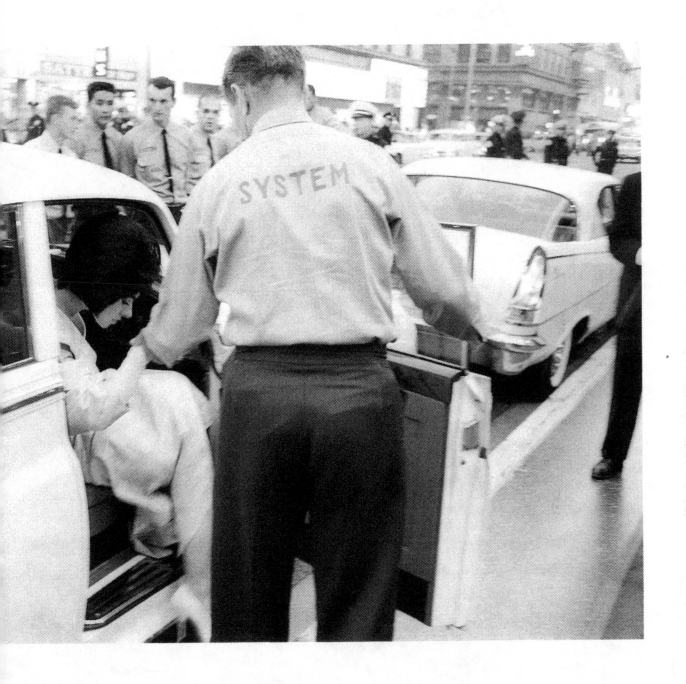

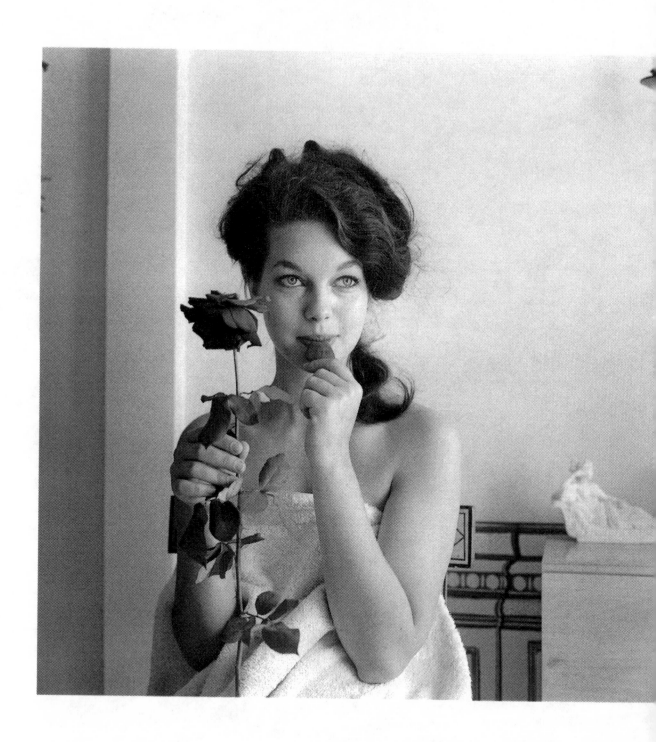

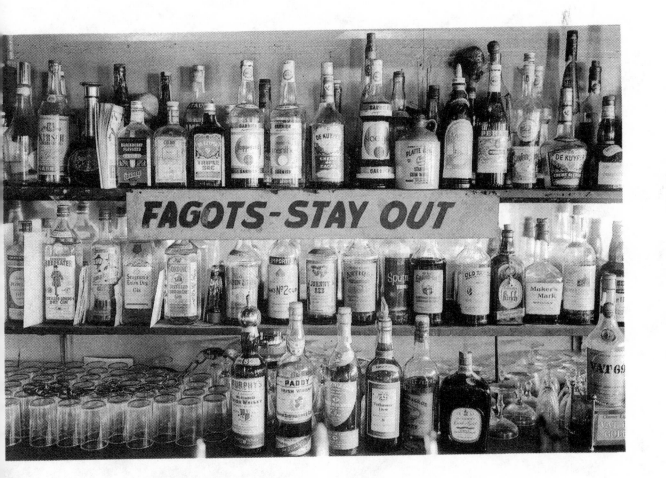

21

death silenced her pool
the day she died
hovered over
her little toy dogs
but left no trace
of itself
at her
funeral

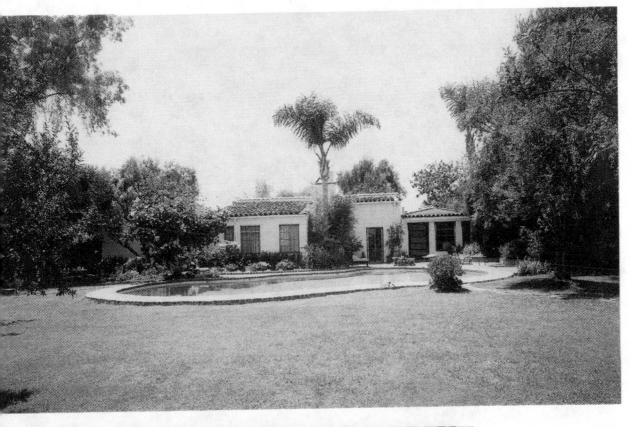

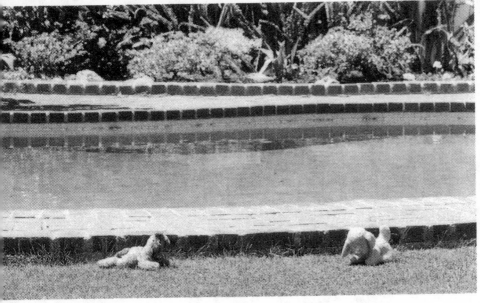

22

death, mama

at death again

mournin auction

pick your tear

bid silently

death

honest death

snatches

leaves sperm guilt

wilting

pools of selfishness

overflowin

onto me too

as my own possessions

have ripped away nonconsulting

layers thick

of blocked up throat lumps

unconceiving

loan me my black suit

hungry bowed head

shell out t the undertaker

all's well that's covered well

all's good that's dead

we're even

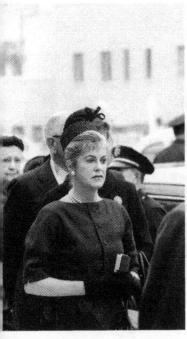

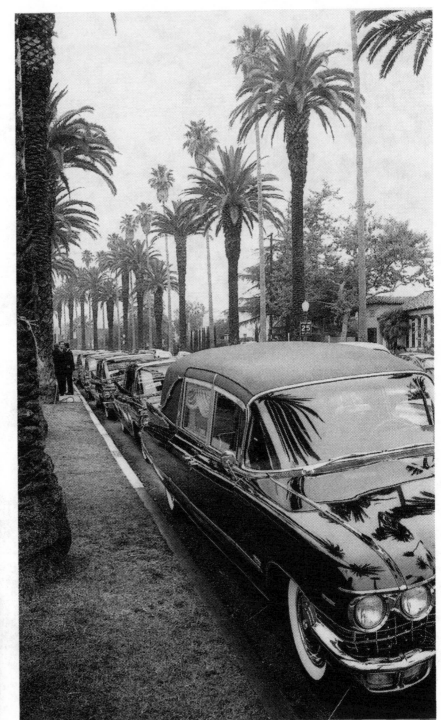

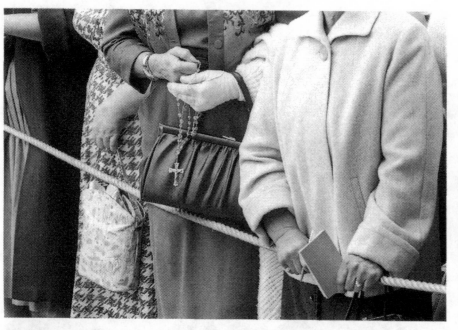

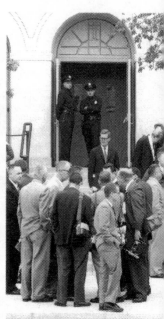

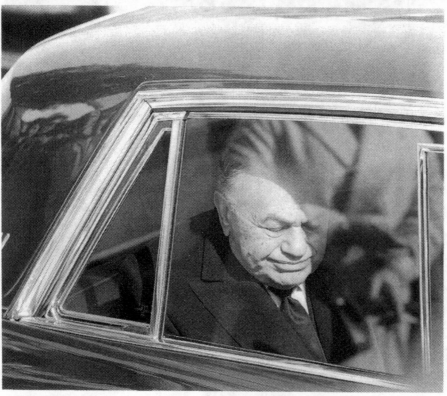

contd at your funerul, we're even

you're taken care of

one more time

grieve disbelieve

order the limit

high precious funeral

priceless?

great event?

ah mama

what care the dead

t drink up their own toasts?

spirits slurping

candle syrup

affects whose emptiness?

aches an sorrow

pain an sorrow

what good what good

(if even with all its deaths

the world has not become

a gentler world) then

how righteous

can the sight of sadness be?

death dresses

the sun gets in its eyes

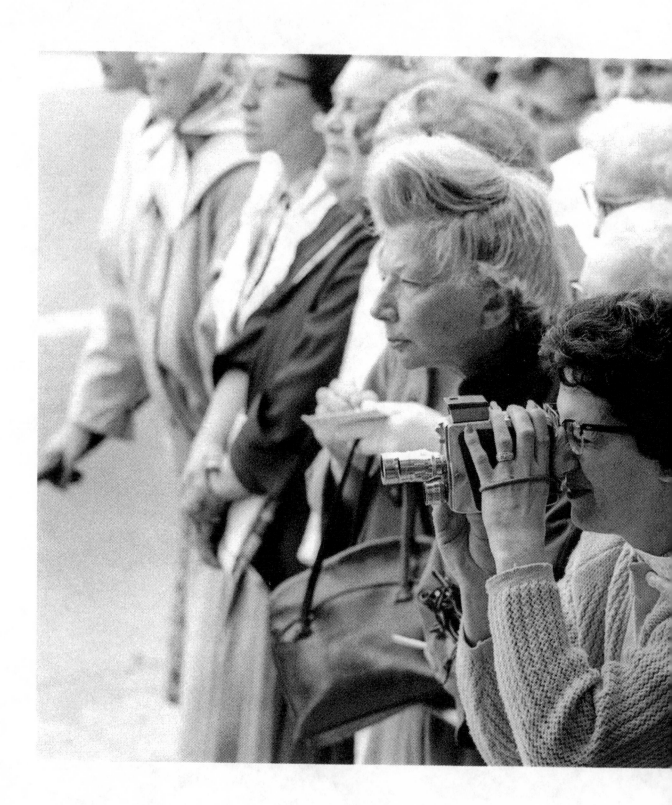

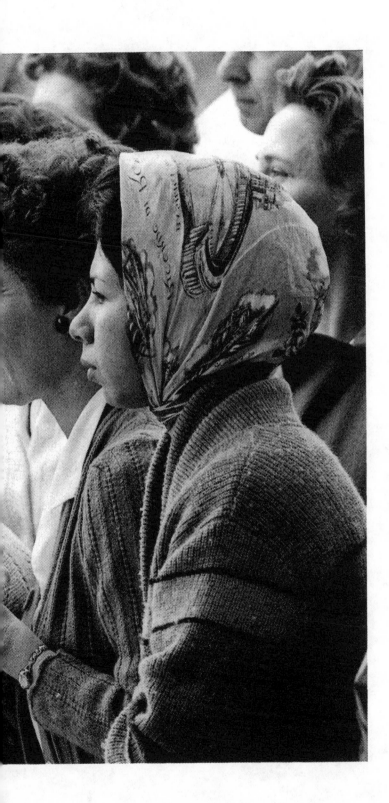

contd blows its nose on notebook pads

partners in crime shake hands

secretly

witnesses hang around

waiting on rosaries

say spyglass prayers

hullucinates

knowin nothingness

unconciousness

no innocence

well lighted

flimsy cloud

holds crowd

dont see no angels

today no one thinks of

himself as the devil

films of pornographic dirt

cant possibly hurt

forsaken coffin's

woodtick slits

gleaming rubbed down boards

burials remain

the same

cemeteries sleep

in the same position

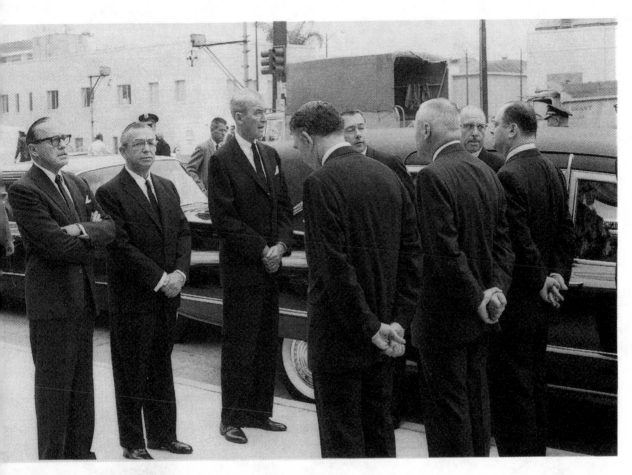

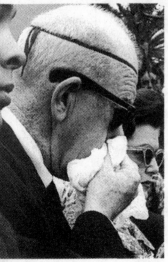

23

a crime not t cry?

can i cast it that freely

or must one be condemned

for not sobbing the loudest?

damned for not cryin at all?

champion stunts

capture the center ring

some have nothin

t look forward

to each day

except a diary

at the end of their day

lookin at life

watchin it being lowered into the ground

unable t change a thing

you too

yes

have committed

some wicked sins

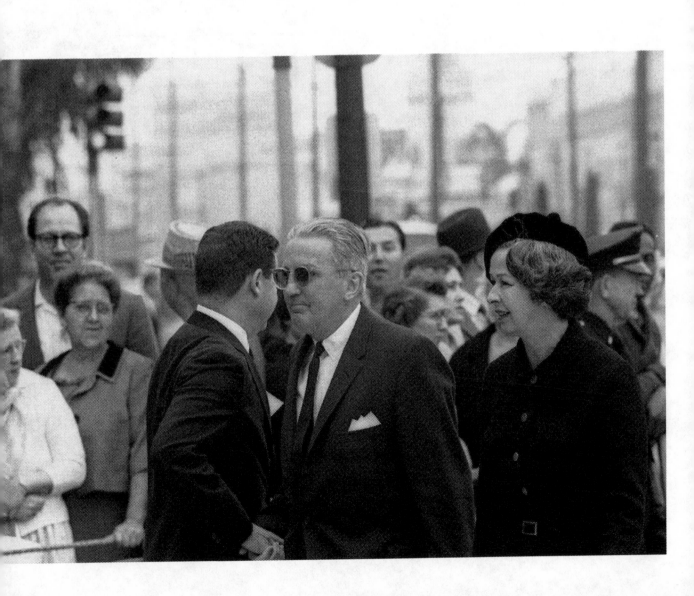

contd receivin this award once

from whom i presumed

kind givers of good wishes

thinkin that they

knew what they were doin

i at least thought

t some degree

acceptin this then

i stood on the

platform an said

"i see something of

myself in the killer

of the president"

some givers booed

screwed their faces up

sneered terribly

i could've stopped

an asked

"is there one person

out there who does

not believe he could

say the same thing?"

ah mama but it's so hard

132

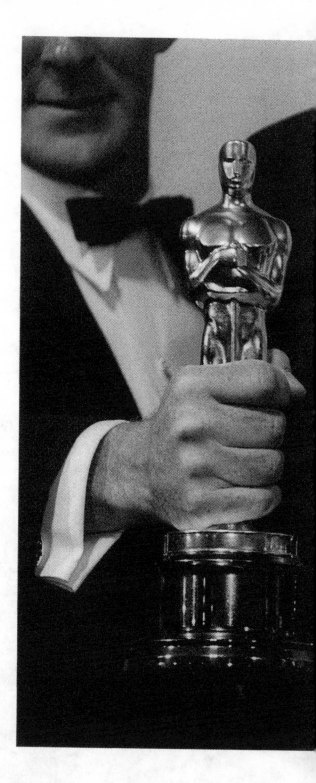

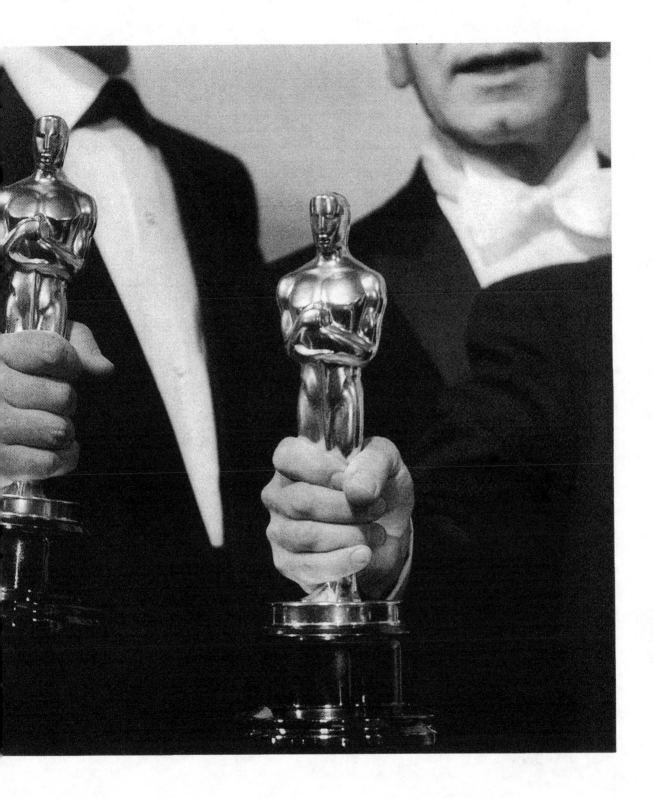

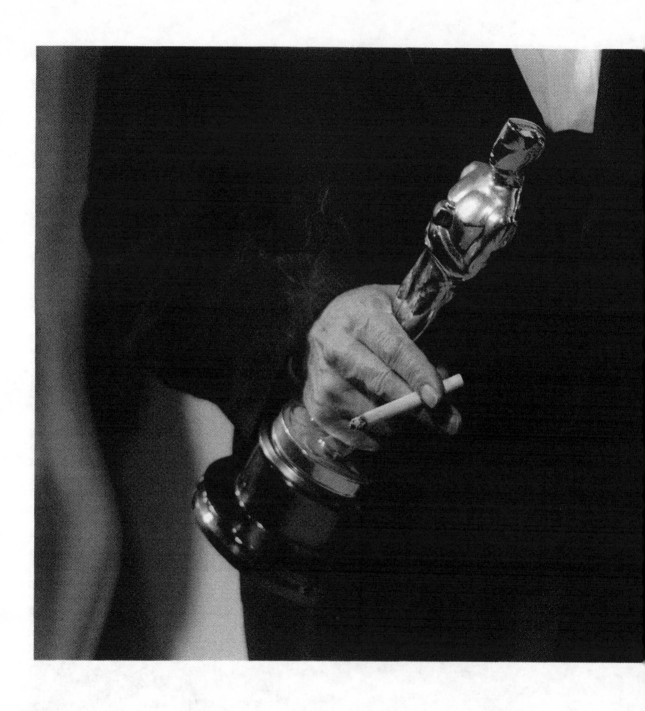

contd for i'm livin in movement

not stoppin an categorizin

the movement

an so

i could not explain t them

about what i was doin

instead i finished

my thoughts

without compromise

(a course

of course

for none

but one)

an stepped down

with my award

which they'd given

much worthless

but for the space it took

priceless

but for the worthless space it took

i later held it

if for no other reason

just t hold it

i cupped it t my breast

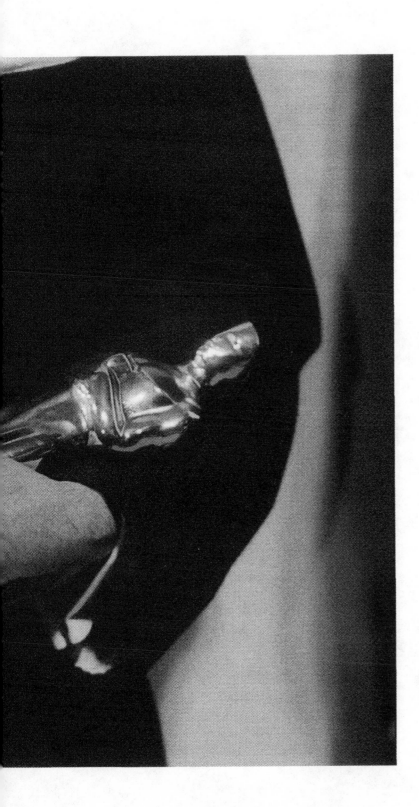

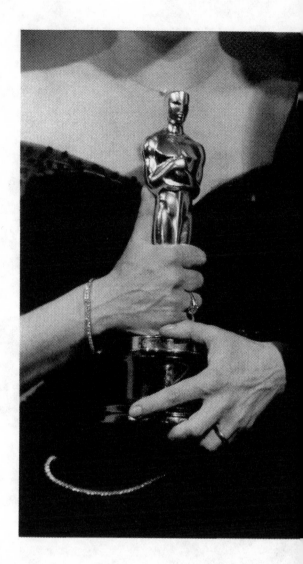

contd looked into its eyes

stroked it

fixed it as a club

pretended it was a barbell

the room was silent mama

the room was silent

except for this hysterical laughin

stemmin from the ridiculousness

of such useless property

but i couldnt tell

who was laughing mama

i couldnt tell if it was me

or this thing

i was holding

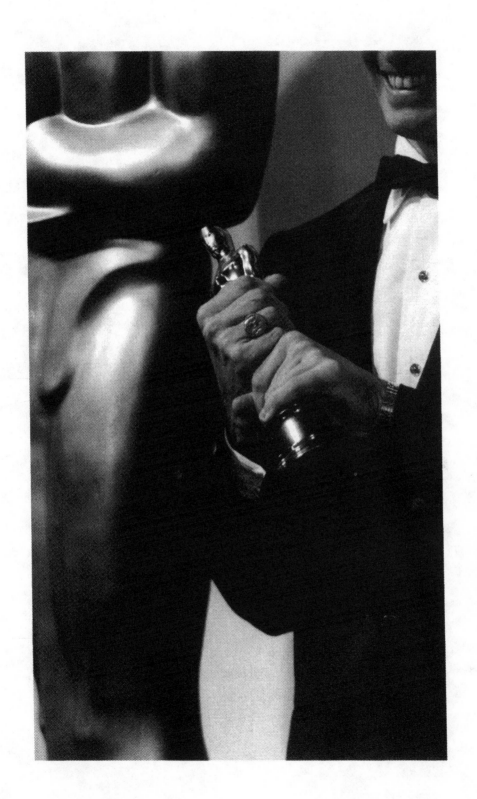

PHOTO INDEX

Special thanks to Sarah Hochman, editor; Chelsea Hoffman,
lead research; and David Rosenthal.

 Simon & Schuster
1230 Avenue of the Americas
New York, NY 10020

Copyright 2008 by Bob Dylan
Photographs copyright 2008 by Barry Feinstein
Foreword by Luc Sante copyright 2008 by Luc Sante
Introduction by Billy Collins copyright 2008 by Billy Collins

For information about special discounts for bulk purchases,
please contact Simon & Schuster Special Sales at
1-800-456-6798 or business@simonandschuster.com.

Designed by Julian Peploe Studio

Manufactured in the United States of America

10 9 8 7 6 5 4 3 2 1

Library of Congress Cataloging-in-Publication Data

Dylan, Bob 1941-
 Hollywood foto-rhetoric : the lost manuscript / Bob Dylan ;
photographs by Barry Feinstein
 p. cm.
 Prose poems.
I. Feinstein, Barry. II. Title.
 PS3554.Y56H66 2008
811'.—dc22

 2008038164

ISBN: 978-1-4391-1255-7